AFRICAN TRIBAL SCULPTURE

by
Margaret Plass

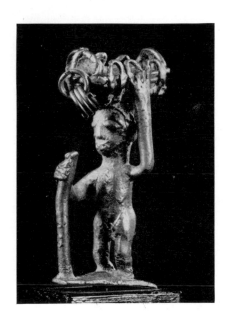

12-A

THE UNIVERSITY MUSEUM
33rd AND SPRUCE STREETS
PHILADELPHIA 4, PENNA.

CONTENTS

Preface (Froelich Rainey) .. 3

African Tribal Sculpture .. 4

Lenders to the Exhibition .. 6

List of Exhibitions Mentioned .. 8

Bibliography .. 9

Catalogue .. 13

Plates .. 58

Index of Tribes .. 120

Map .. 121

PREFACE

This exhibition of African tribal sculpture has been assembled through loans from eleven museums and twenty-four private collectors in Europe, Africa, and America. Our intention has been to show the finest examples available from each of the distinct tribal areas in West Africa, and thus to give the visitor an over-all impression of African art at its best.

Nearly forty of the pieces in the exhibition are from the Webster Plass Collection now in the keeping of the British Museum. This large number of objects from one collection may be explained by the fact that Mr. Plass, over a period of years, was able to assemble one of the finest private collections of African art in the world. Moreover his first enthusiasm for African art developed in the University Museum and therefore it seems to us fitting that a large part of the collection should now be shown as a memorial to him.

Mrs. Webster Plass has not only brought this collection to us from the British Museum in London, but has arranged for the loan of all other pieces in the exhibition. I wish to express the sincere gratitude of the Board of Managers to all those private collectors and museum directors who have lent to us fine objects from their collections. They have all been exceedingly generous and helpful.

We are most grateful to Mr. William Fagg, Deputy Keeper of the Department of Ethnography, The British Museum, for his invaluable advice and assistance when in America this spring. Mr. David Crownover, of our Museum, designed and arranged the exhibition. Miss Geraldine Bruckner, our Registrar, has contributed services over and beyond the call of duty, and Miss Ellen Kohler has edited this catalogue.

It is to all these that we are primarily indebted for whatever success this exhibition may have in Philadelphia.

FROELICH RAINEY

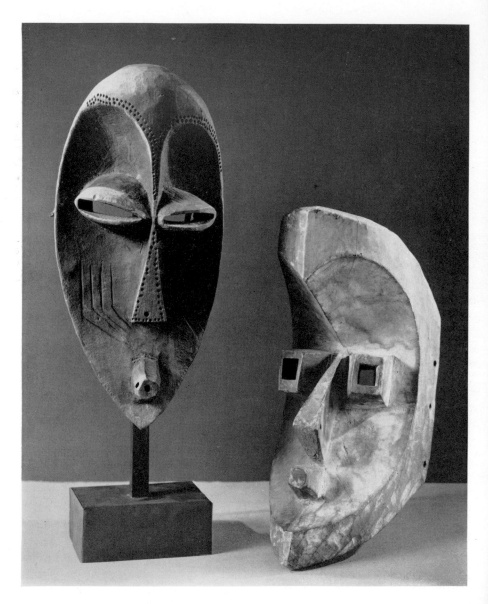

25-A 25-B

AFRICAN TRIBAL SCULPTURE

Aesthetic merit rather than ethnographical interest has been the main criterion which has influenced the selection of pieces for this exhibition of the tribal sculpture of Africa; that is to say that we have tried not only to represent the main styles of Negro sculpture, but to represent them by the best available works of their best artists, according to standards which are intended to be as rigorous as those applied in forming a major exhibition of, say, the works of the Dutch or Italian masters. It is, in fact, an opportunity for people to assess for themselves the genius of the African masters of woodcarving and bronze-founding.

Since so few of us are yet familiar with the strange forms and rhythms of tribal art, it is not always easy to appreciate these exotic and still obscure sculptures without reservation. Holding to the aesthetic traditions of our industrial society, we are unable to break through the philosophical barrier which lies in the way of full understanding. Only eyes unconditioned to realism by photography and unbiased by the Greeks' introduction of mensuration in drawing can, without mental effort, see them truly.

Every tribe or sub-tribe has its own identifiable style carried on in the tradition of many generations of carvers. Therefore the age of a sculpture is the least useful or necessary thing for us to know about it. The apparent age of a piece is apt to bear very little relation to its actual age. Thus, carvings of the Yoruba tribe of Nigeria brought to the City Museum of Ulm in South Germany in the seventeenth century, and preserved there in a glass case for over two hundred years, may very well look younger than similar sculptures made ten years ago in Yorubaland and subjected to all the perils of the hot, steamy climate, the hungry termites and borers, the molds and fungi that beset pieces that have been in actual use in Africa for sometimes

only a few months. It is this ephemeral quality in African art which makes for continuous evolution and development, there being few relics of the past to tie the sculptor to hidebound conventions. There can be no dating of these sculptural traditions. They may or may not have existed before the ancient arts of Egypt.

It is not enough to look at these works as pure art, complete in themselves. We must apprehend something of the traditions and cultures of which they are a part and a manifestation. Therefore the documentation of the catalogue presents as many facts as we can ascertain about the provenance, material, purpose and use of each object as well as an account of its former owners, when known, and the books and exhibition catalogues in which it has been described.

There is a brief bibliography appended of books and articles referred to in the text, and an asterisk marks those publications which may be purchased at the sales desk. Many of the publications can also be found in the library of the University Museum for those who wish to read further on African art.

Here are shown some two hundred works of art, lent to us by the great museums and generous private collectors of Europe and America. Do not attempt to estimate their aesthetic value by our modern Western standards, but look at them for what they are, representations of the great sculptural traditions of Africa, and appreciate the beauty of these created objects for their own sake.

With a little humility and a great deal of imagination, we can see that these works of art are not limited in meaning. Because their forms have something of the universality and directness of expression of the best music, their broader significance is accessible to each person who enjoys them out of his own aesthetic experience.

LENDERS TO THE EXHIBITION

Museums

The Allen Memorial Art Museum, Oberlin, Ohio
The American Museum of Natural History, New York
The Baltimore Museum of Art, Baltimore. (The Wurtzburger Collection)
The British Museum, London. (The Webster Plass Collection)
The Brooklyn Museum, Brooklyn
The Commercial Museum, Philadelphia
The Ethnographical Museum, Antwerp
The Museum of Modern Art, New York
The Peabody Museum, Salem, Massachusetts
The University Museum, Philadelphia
The Yale University Art Gallery, New Haven. (The Linton Collection)

Private Collectors

Anonymous Collector, New York
Dr. D. Biebuyck, Bukavu, Belgian Congo
Mr. Julius Carlebach, New York
Mr. and Mrs. René d'Harnoncourt, New York
Mr. Albert Duveen, New York
Mr. Eliot Elisofon, New York
Mr. William Fagg, London
Dr. and Mrs. John Porter Foley, Jr., New York

Prof. Nelson Goodman, Philadelphia
Mr. and Mrs. R. Sturgis Ingersoll, Philadelphia
Mr. John J. Klejman, New York
Miss Susanne C. Klejman, New York
Mr. M. L. J. Lemaire, Amsterdam
Mr. and Mrs. James M. Osborn, New Haven
Mr. Eric Peters, New York
Mrs. Webster Plass, New York
Mr. Frederick Pleasants, New York
M. Charles Ratton, Paris
Mr. and Mrs. Gustave Schindler, New York
Mr. and Mrs. Frederick Stafford, New York
Mr. and Mrs. E. Clark Stillman, New York
Mr. E. Storrer, Zürich
Mr. James Johnson Sweeney, New York
Prof. Dr. P. J. Vandenhoute, Oostaker, Belgium

LIST OF EXHIBITIONS MENTIONED

Paris, 1923. "Exposition d'Art Indigène des Colonies Françaises et du Congo Belge," Louvre, Musée des Arts Decoratifs.

Paris, 1930. "Exposition d'Art Africain et d'Art Océanien," Théâtre Pigalle.

Brussels, 1930. "Les Arts Anciens de l'Afrique Noire," Palais des Beaux Arts.

New York, 1935. "African Negro Art," Museum of Modern Art.

Paris, 1936. "La Sculpture des Noirs de l'Afrique," Théâtre Edward VII.

Antwerp, 1937. "Kongo-Kunst," Stads Feestzaal.

London, 1948. "40,000 Years of Modern Art," Institute of Contemporary Arts.

Cambridge, 1948. "The Art of Primitive Peoples," Fitzwilliam Museum of Art.

San Francisco, 1948. "African Negro Sculpture," The De Young Memorial Museum.

London, 1949. "Traditional Art of the British Colonies," Royal Anthropological Institute.

London, 1951. "Traditional Art from the Colonies," Imperial Institute.

London, 1953. "The Webster Plass Collection of African Art," The British Museum.

Brooklyn, 1954. "Masterpieces of African Art," Brooklyn Museum.

Baltimore, 1954. "The Wurtzburger Collection of African Sculpture," Baltimore Museum of Art.

New Haven, 1954. "The Linton Collection of African Sculpture," Yale University Art Gallery.

Oberlin, 1956. "African Negro Sculpture," Allen Memorial Art Museum.

BIBLIOGRAPHY

*Publications marked with a star may be purchased at the
sales desk in the Museum.*

★Adam = Adam, Leonhard, *Primitive Art,* New York, 1949.

Andersson = Andersson, Efraim, *Les Kuta,* Vol. I, Studia Ethnographica
Upsaliensia. No. VI, Upsala, Sweden.

Baltimore = *The Wurtzburger Collection of African Sculpture,* Baltimore
Museum of Art. Baltimore, 1954.

BAMAM = *African Art,* Bulletin of the Allen Memorial Art Museum,
Feb., 1956. Oberlin, Ohio.

Basler = Basler, Adolphe, *L'Art chez les peuples primitifs.* Paris, 1929.

Brooklyn = *Masterpieces of African Art,* The Brooklyn Museum. Brook-
lyn, 1954.

Christensen = Christensen, Erwin O., *Primitive Art.* New York, 1955.

Clouzot and Level, 1919 = Clouzot, H., and Level, A., *L'Art negre et l'art
océanien.* Paris.

Clouzot and Level, 1925 = Clouzot, H., and Level, A., *Sculptures
africaines et océaniennes.* Paris.

Donner = Donner E., "Kunst und Handwerk in No-Liberia," *Baessler-
Archiv* 23 (1940), pp. 45-112. Berlin.

Einstein = Einstein, Carl, *Negerplastik,* Leipzig, 1915.

Fagg, 1947 = Fagg, William, "Two Woodcarvings from the Baga of
French Guinea," *Man,* 1947, article no. 113. Royal Anthropological
Institute, London.

Fagg, 1949 = Fagg, William, "Traditional Art of the British Colonies,"
Man, 1949, article no. 145. Royal Anthropological Institute, London.

Fagg, 1951a = Fagg, William, "Art in the Gold Coast," *West African
Review,* July 1951. Liverpool.

Fagg, 1951b = Fagg, William, "De l'art des Yoruba," *Présence africaine: L'Art nègre* 10-11 (1951), pp. 103-35. Paris.

Fagg, 1951c = Fagg, William, "Tribal Sculpture in the British Colonies," *Journ. Roy. Soc. of Arts,* 27 July, 1951. London.

Fagg, 1952a = Fagg, William, "A Nigerian Bronze Figure from the Benin Expedition," *Man,* 1952, article no. 210. Royal Anthropological Institute, London.

Fagg, 1952b = Fagg, William, "The Plass Collection," *West Africa* (weekly), 15 March, 1952. London.

Fagg, 1953a = Fagg, William, "On the Nature of African Art," *Mem. and Proc. Manchester Lit. and Phil. Soc.,* 44 (1953). Manchester.

★Fagg, 1953b = Fagg, William, *The Webster Plass Collection of African Art.* The British Museum, London.

Griaule, 1938 = Griaule, Marcel, *Masques dogons,* Trav. et Mem. de l'Inst. d'Ethn. 33 (1938). Paris.

Griaule, 1950 = Griaule, Marcel, *Folk Art in Black Africa.* London. (Tr. from *Arts de l'Afrique noire.* Paris, 1947).

★Hall, 1917 = Hall, H. U., "Some Gods of the Yoruba," *Univ. Mus. Journ.* VIII, 1.

✷Hall, 1919 = Hall, H. U., "Examples of African Art," *Univ. Mus. Journ.* X, 3.

✷Hall, 1920 = Hall, H. U., "Fetish Figures of Equatorial Africa," *Univ. Mus. Journ.* XI, 1.

★Hall, 1924 = Hall, H. U., "African Cups Embodying Human Forms," *Univ. Mus. Journ.* XV, 3

★Hall, 1927 = Hall, H. U., "Two Masks from French Equatorial Africa," *Univ. Mus. Journ.* XVIII, 4.

★Hall, 1928 = Hall, H. U., "Twins in Upper Guinea," *Univ. Mus. Journ.* XIX, 4.

★Hall, 1938 = Hall, H. U., *The Sherbro of Sierra Leone,* University Museum, Philadelphia.

Himmelheber = Himmelheber, Hans, *Negerkünstler.* Stuttgart, 1935.

I.C.A., 1948 = *40,000 Years of Modern Art* (catalogue of The Institute of Contemporary Arts exhibition). London.

Imp. Inst., 1951 = *Traditional Sculpture from the Colonies* (illustrated handbook of the Colonial Office exhibition at the Imperial Institute). London.

Kjersmeier = Kjersmeier, Carl, *Centres de style de la sculpture nègre africaine* (4 vols.). Paris and Copenhagen 1935-38. See also his abridged *African Negro Sculptures*. Copenhagen, 1947.

Lem = Lem, F.-H., *Sudanese Sculpture* (Tr. from *Sculptures soudanaises*). Paris, 1948.

Life 1952 = "Mystic Art of Tribal Africa," with photographs by Eliot Elisofon, *Life Magazine,* 8 Sept., 1952. New York.

von Luschan = von Luschan, Felix, *Altertümer von Benin* (3 vols.). Berlin and Leipzig, 1919.

Minotaure, 1933 = "Casques et masques de danse du Soudan français," *Minotaure,* no. 2: Mission Dakar-Djibouti, 1931-33. Paris.

Olbrechts = Olbrechts, Frans M., *Plastiek van Kongo*. Antwerp, 1946.

Pijoan = Pijoan, José, *Summa Artis,* Vol. I. Madrid, 1944.

Plass = Plass, Margaret, "Poids à or des Ashanti," *Présence africaine: L'Art nègre* 10-11 (1951), pp. 163-66. Paris.

Portier and Poncetton = Portier, A., and Poncetton, F., *Les arts sauvages: Afrique*. Paris, 1930.

★R.A.I., 1949 = *Traditional Art of the British Colonies* (illustrated catalogue of the Royal Anthropological Institute exhibition). London.

Radin and Sweeney = Radin, Paul, and Sweeney, James J., *African Folktales and Sculpture*. New York, 1952.

Read and Dalton = Read, C. H., and Dalton, O. M., *Antiquities from the City of Benin and Other Parts of West Africa in the British Museum*. London, 1899.

Schmalenbach = Schmalenbach, Werner, *L'Art nègre*. Bâle. 1953.

Schwab = Schwab, George, *Tribes of the Liberian Hinterland,* Pap. Peabody Mus. Am. Arch. and Ethn. 31. Cambridge, Mass., 1947.

Siroto = Siroto, Leon, "A Mask Style from the French Congo," *Man,* 1954, article no. 232. Royal Anthropological Institute, London.

Sweeney = Sweeney, James J., *African Negro Art* (catalogue of Museum of Modern Art exhibition). New York, 1935.

Talbot = Talbot, P. Amaury, *Tribes of the Niger Delta*. London, 1932.

Tempels = Tempels, Placide, *La Philosophie bantoue* (tr. from the Flemish). Paris, 1949

★Torday = Torday, E., "The New Congo Collection," *Univ. Mus. Journ.* IV, 1 (1913).

★Trowell = Trowell, Margaret, *Classical African Sculpture*. London, 1954.

Underwood, 1947 = Underwood, Leon, *Figures in Wood of West Africa*. London, 1947.

12

Underwood, 1948 = Underwood, Leon, *Masks of West Africa*. London, 1948.

★Underwood, 1949 = Underwood, Leon, *Bronzes of West Africa,* London, 1949.

Vandenhoute = Vandenhoute, P. J. L., *Classification stylistique du masque Dan et Guéré de la Côte d'Ivoire occidentale,* Med. van het Rijksmus. voor Volkenk., no. 4. Leiden, 1948.

★Wieschhoff = Wieschhoff, H. A., *The African Collections of the University Museum,* Univ. Mus. Bulletin XI, 1-2 (March, 1945). Philadelphia.

★Wingert = Wingert, Paul S., *The Sculpture of Negro Africa*. New York, 1950.

Y.U.A.G. = *The Linton Collection of African Sculpture,* Yale Univ. Art Gallery. New Haven, 1954.

CATALOGUE

Pieces marked with a star are illustrated in the plates.

1. DOGON

The Dogon, a pagan tribe of some 100,000, living on cliff-sided plateaus like the mesas of southwestern United States, in the Bandiagara escarpment area along the upper reaches of the Niger River, are, with their neighboring tribes, the Bambara, the Bobo and the Mossi, the surviving remnants of the primitive peoples of the Sudan to escape the unifying flood of Islam which overwhelmed this part of Africa more than a thousand years ago. Their cultural independence is now not entirely complete as they must have commercial dealings with their Moslem neighbors on the great plains all about them. Their costumes, for instance, and some of their customs are now in part influenced by Islam. They are agricultural people, but working with soil fertile only when compared with the not-far-off Sahara, and not so easily cultivated as the luxuriantly abundant land of the Guinea Coast and the rain forest area. They also live by the hunt, using primitive weapons, spears, clubs and knives. Their art is the most abstract, the most architectural or geometrical of all the tribal cultures, reflecting the geological formations about them. Even their houses, like pointed beehives, are built on and of their native rocks. Their religion and, therefore, their art are concerned with fertility of the soil and of the animals more than of the tribe, although increase in general remains, as everywhere in Negro Africa, a dominant motivation in their lives.

1-A. Wooden figure of a standing female wearing a labret or lip plug, and a classic in the field of African art. It was one of the first pieces from Africa to be widely exhibited and appreciated in Europe before coming to America, and is as "Cubist" a carving as ever was produced by any modern sculptor. H. 30". Mr. James Johnson Sweeney, New York.

> *Exh.* Paris, 1923; New York, 1935; Brooklyn, 1954. *Ill.* Kjersmeier, vol. 1, pl. 20; Sweeney, no. 13; Radin and Sweeney, pl. 43.

1-B. Wooden figure, standing male, said to have been used in the cult for the souls of dead pregnant women, but perhaps not restricted to this cult in use. H. 17½". The University Museum.

1-C. Wooden figure, seated female, another of those carved for many purposes. This may be an ancestor figure (to house the soul of the ancestor) or be part of the paraphernalia of one of the cults or secret societies, or may even belong to the personal altar of a living person. The long cylindrical plug in the lower lip represents a type of labret used in former times by Dogon women. H. 22¾". The University Museum.

> *Exh.* San Francisco, 1948; Brooklyn, 1954. *Ill.* Wingert, pl. 7; Brooklyn, No. 7.

1-D. Wooden figure, seated female, found with 1-B and possibly related to the cult for the souls of dead pregnant women. Such figures were kept in rock sanctuaries, closely guarded and highly valued. H. 21½". The University Museum.

> *Exh.* San Francisco, 1948. *Ill.* Wingert, pl. 8; Wieschhoff, fig. 26.

★1-E. Wooden mask with superstructure of elongated human figure. This spectacular mask is of the familiar "architectural" type with rectilinear features, in fine contrast to the abstract human figure rising above it. H. 44¼". Mr. John J. Klejman, New York.

> *Exh.* Oberlin, 1956. *Ill. BAMAM,* No. 8.

★1-F. Wooden mask, surmounted by a tall female figure. H. 40½". Mr. John J. Klejman, New York.

1-G. Wooden figure, probably representing an ancestor imploring rain from the sky. Such so-called "root-carvings" are attributed to an older "Tellem" people by the Dogon, but the style seems to be ancestral to the later work. H. 10". Mr. John J. Klejman, New York.

★1-H. Wooden granary door to protect the grain from birds and beasts. The parallel rows of abstract human figures probably represent ancestors. H. 20". Mr. and Mrs. Gustave Schindler, New York.

1-I. Lock of hard wood for a granary door, simply cross-hatched and surmounted by a male and female stylized human figure (cf. 1-H). It is of a type borrowed from the Arabs. At the back four metal pins engage with four holes in the wooden bolt. It was collected by the Mission Griaule, 1931. H. 6¼". The British Museum, Webster Plass Collection.

15

2. BAMBARA

The Bambara are a much larger tribe than the Dogon, numbering some 1,000,000. They live to the west and south of the Dogon and their art is equally abstract, with even greater emphasis on agricultural and animal fertility. In the hunt they use burning of the bush as a means of driving out the animals, and before the hunt dancers imitate the leaping of the antelope in a ritual ceremonial dance. Their most important plays reënact legends about the spirits of agriculture and fertility.

2-A. Wooden figure, seated female, closely related to 2-F, and a great work of art. It is of the type used in certain funerary rites, but its positive use in any cult is still not definite. It is probably concerned with ancestor propitiation. H. 21″. The University Museum.
 Exh. San Francisco, 1948; Brooklyn, 1954. *Ill.* Wingert, pl. 1.

★2-B. Wooden dance headdress, called *chi wara* by the Bambara, in the form of an antelope treated in a highly abstract manner. When in use, such head-dresses are fixed to a basketwork cap. H. 42¾″. Mr. and Mrs. Gustave Schindler, New York.
 Exh. Oberlin, 1956. *Ill. BAMAM,* No. 1.

2-C. Wooden dance headdress. This is another *chi wara,* with the animal's horns in a horizontal position, treated in a more realistic fashion than 2-B. H. 32″. Mr. John J. Klejman, New York.

2-D. Wooden dance mask with stylized human face behind which is a comb-like projection with seven teeth. The mask is completely covered with cowrie shells interspersed with groups of red seeds. According to Kjersmeier, such masks are for dances of the young boys' N'tomo society. H. 23½″. Mr. Julius Carlebach, New York.

2-E. Wooden dance mask of hard wood painted white with reddish dots, in the form of a jackal- or dog-head, carved in an angular manner with the upper jaw reduced to handlelike projection. The attribution to the Bambara is conjectural. L. 14½″. The British Museum, Webster Plass Collection.
 Exh. Oberlin, 1956. *Ill.* Fagg 1953b, pl. 4; *BAMAM,* No. 2.

2-F. Wooden seated figure, a funerary statue representing a distinguished ancestor, of a type that was used beside the corpse at funerals. The forearms are broken off. H. 25½″. Mr. Julius Carlebach, New York.

★2-G. Wooden dance mask, brass plated. The brass overlay on this old mask is decorated with small circles of perforated dots, possibly showing Arab influence. This narrow type of face mask is attributed to the Marka, who appear to be a Bambara sub-tribe. H. 16½″. Mr. and Mrs. James M. Osborn, New Haven.
 Exh. New Haven, 1954. *Ill.* Y.U.A.G., No. 6.

16

3. BOBO

The Bobo, a small tribe of the French Sudan who live also in the Ivory Coast along the Upper Volta River, are notable for their bold use of color in art. They seem in many ways a more extrovert people than the Dogon and Bambara.

3-A. Wooden helmet mask. This rare old mask with bulbous eyes, protruding mouth, and a long slender nose has a central crest running from the front to the back of the head. It is carved of hard wood and shows some traces of red and blue paint. It was collected among the Bobo-Fing sub-tribe and is perhaps by the same carver as one in the Webster Plass Collection (Fagg. 1953b, pl. 5). H. 14⅞″. Mr. John J. Klejman, New York.

3-B. Wooden dance mask of small size, representing the head of an antelope and carved with incised triangles and other geometrical patterns painted red, white and black. H. 10″. Mr. Julius Carlebach, New York.

★**3-C. Wooden mask** polychromed in the Bobo style in white, red and black, in the form of the stylized head of a rooster, a piece of great aesthetic appeal and exceptionally well sculptured. An almost identical piece in the Berlin Museum is ascribed to the Mossi. H. 22″. Mr. and Mrs. Frederick Stafford, New York.

4. MOSSI

The Mossi are a very large tribe of perhaps a million and a half, now almost entirely Islamized and therefore producing much less art than the tribes described previously.

★**4-A. Dance headdress** in the form of a stylized antelope head, with painted geometrical decoration, probably used in dances similar to the dances using the *chi wara* among the Bambara. A similar piece in the Musée de l'Homme is attributed to the Kurumba. H. 18″. The Baltimore Museum of Art, Wurtzburger Collection.
Ill. Baltimore, cover design.

5. BAGA

The Baga are a small tribe of the Guinea Coast, who probably migrated in former days from the Sudan, as they show some Bambara influence. When Prof. Labouret of the Musée de l'Homme studied them in the early thirties, he found the Baga largely Islamized, but from a number of still existing fetish villages which maintained their pagan religion and their very important Simo secret society, he made an excellent collection for the Museum.

17

★5-A. Wooden female bust with carrying yoke, a great Nimba mask of the Simo, is the only one of its type in America out of perhaps eight that have been collected from the Baga people. It has the power, dignity and intense emotional drive seen only in great sculpture. H. 45½″. Anonymous Collector, New York.

Exh. Brooklyn, 1954.

5-B. Wooden carving of female bust, on flaring pedestal, consisting of a massive and noble head with slender salient nose joined to the crest of the coiffure. The head, placed well forward, is joined by a cylindrical neck to the rounded shoulders and flat pendent breasts. Carved from the same large block of hard greyish wood is a flaring pedestal. This carving is of the same type as the great Nimba masks (cf. 5-A) with shoulder yokes used in the Sino secret society and is said to have been worn on the head, probably attached to a basket-work headdress. It was collected by Prof. Labouret of the Musée de l'Homme in 1932. H. 25¾″. The British Museum, Webster Plass Collection.

Exh. London, 1948; Oberlin, 1956. *Ill.* I.C.A., 1948, p. 18; Fagg 1952b; Fagg 1953b, pl. 7; Trowell, pl. 30B; *BAMAM,* No. 10.

★5-C. Wooden carving with round pedestal socket, of great ethnological as well as aesthetic interest. Two similar pieces, one at the British Museum and one at the Musée de l'Homme are described by William Fagg (1947); others have since been reported in the Berlin collection and at Dakar (I.F.A.N.). The carving consists of two parts, the pedestal being carved separately from the main portion but of the same hard greyish wood. It seems to represent a human head with features reduced to a bulging forehead and salient nose and with the mouth drawn out into a long, pointed snout apparently representing that of a crocodile (though the impression given in the carving is of a bird). The surface is well finished and partially cross-hatched. The piece seems well adapted to being carried in the hand when taken from its pedestal. H. 24″; L. 31½″. The Commercial Museum, Philadelphia.

6. MENDE

The sculpture of Sierra Leone, a British Protectorate of the Guinea Coast, falls into two classes. There are the ancient soapstone carvings, called Nomori, and there are the helmet masks and the figures, mostly connected with the Sande, or Bundu, the women's secret society, the most powerful in Sierra Leone except for the men's Poro Society.

6-A. Wooden figure, female, legless, rising from a shallow bowl, used as a divination figure in the rites of the Bundu secret society of the Mende tribe. H. 17½″. The University Museum.

Exh. San Francisco, 1948. *Ill.* Wingert, pl. 12.

6-B. Wooden dance mask. A helmet mask of blackened soft wood with very small face and high and elaborate coiffure surmounted by straddling male and

18

female figures, of the type worn by the dean of women in the Sande or Bundu secret society rites. The rest of her costume is a great cloak of vegetable fiber dyed black, making the dancing figure resemble an enormous hairy beehive. H. 16". The University Museum.

7. THE DAN TRIBES

The Dan Tribes are a group of people going by various names, Dan, Mano, Bassa, etc. They are widespread in eastern Liberia, the western part of the Ivory Coast, and the adjoining area of French Guinea. Their art is usually confined to masks although some standing figures, ladles, and brass figures are also found among them. They live in symbiosis with the Ngere tribes (8).

7-A. Wooden mask in the sub-style of Flanpleu village. According to Prof. Vandenhoute of Belgium, its owner, who collected it in the field in 1938, its name is "Eater of Carrion," and it was carved by the sculptor Kmantadouwe, who died in 1904. This beautiful mask has a brilliantly polished patina, marked with traces of white earth and crushed kola nuts used on it at times of sacrifice. H. 6½". Prof. Dr. P. J. Vandenhoute, Oostaker, Belgium.
Ill. Vandenhoute, fig. 1.

7-B. Group of miniature wooden masks, collected by Dr. G. W. Harley in Liberia. They are worn as badges of initiation or amulets. Cf. Donner, p. 92. H. 3 to 4". Mr. and Mrs. James M. Osborn, New Haven.
Ill. Schwab, fig. 91.

★7-C. Wooden mask belonging to the powerful Poro secret society. It still wears its original headdress of copper and iron blades, cloth and fiber hair. The band across the eyes is painted red. It belongs to the Mano, one of the Dan tribes, and was collected by Dr. Harley in Liberia for Prof. Ralph Linton. H. 12". The Yale University Art Gallery, New Haven, Linton Collection.
Ill. Y.U.A.G., No. 28.

7-D. Wooden dance mask, of markedly cubist style. Dr. Harley collected this mask in Liberia and it is in one of the classic styles used in the Poro Society. A somewhat similar mask was collected by Prof. P. J. Vandenhoute among the northern Dan of the Ivory Coast, and is classified by him as of the Dan-Ngere style. H. 9¼". Mr. and Mrs. James M. Osborn, New Haven.
Ill. Y.U.A.G., No. 25.

8. THE NGERE TRIBES

By the Ngere tribes are here meant not only the Ngere or Gere proper but those other tribes of the Dan-Ngere complex in Liberia and the Ivory Coast whose art seems to belong to the Ngere tradition, being distinguished

by a certain fierce and gross quality from the generally smooth and delicate restraint of the classical Dan style. The Poro men's society is a dominating influence throughout this complex of tribes.

8-A. Wooden dance mask, painted black. Seemingly a synthesis of human and animal features, it is used in the circumcision rites of the Ngere. The lower jaw is separately carved and movable with the chin when worn. H. 9¾". The University Museum.

★8-B. Wooden mask, complete with all its accoutrements of bells, cloth, etc., in typical Ngere style. When complete with its cloth costume and worn by the African dancer of the Poro society for whom it was created, its impressive qualities can easily be imagined. H. 11½". The Allen Memorial Art Museum, Oberlin, Ohio.
Exh. Oberlin, 1956. *Ill. BAMAM,* No. 15.

8-C. Wooden mask, painted black, with human and animal features. The mouth has a mustache of human hair. H. 8". Dr. and Mrs. John Porter Foley, Jr., New York.

8-D. Wooden mask. A pair of upraised arms issue surrealistically from the flat brow of this cubistic mask, which has a thick black patina, while teeth, hands and parts of the coiffure are painted white. It belongs to the Grebo, a coastal tribe of the Ngere tradition around Cape Palmas. This style from the mouth of the Cavally River shows a remarkable parallelism with that of the western Ijo of the Niger Delta. H. 14". The Peabody Museum, Salem, Mass.
Exh. San Francisco, 1948. *Ill.* Wingert, pl. 49.

★8-E. Wooden mask. This is in Grebo style closely similar to 8-D. The flat boat-shaped plane of the face is produced still further upwards, and the whole is painted a dazzling white. A number of holes are pierced in the eye region, and the mask is clearly made to be worn in front of the face (as opposed to the horizontal position of Ijo masks). H. 26¼". Anonymous Collector, New York.

9. GURO

The Guro are a small Ivory Coast tribe of about 100,000 living between the Dan Tribes and the Baule. Their art is sophisticated and smooth, closely allied with the style of the Baule, but often more vigorous and seemingly sincere. The language of the Guro is allied with that of the Dan Tribes while the Baule are an Agni people, related more closely to the Ashanti. Masks and heddle pulleys from the Guro are found in most museums and private collections; whole figures are very rare. These pulleys with their tops carved as animals or humans are as common with the Guro as with the Baule, and are made for use with the narrow horizontal looms operated by the men of both tribes.

20

9-A. Wooden dance mask in the form of a horned antelope with human nose, and with classical Guro tribal markings. It is an outstanding example of the mask used in the Zamle dance by the Guro people, this secret society being one of three of great importance in Guro culture. The surface of the mask has a fine deep brown patina, the teeth, horns, eyes, etc., being painted with red pigment; there are holes on each side of the mouth at the back for a wooden bit to be gripped in the wearer's teeth. H. 20½". The British Museum, Webster Plass Collection.

> *Exh.* Paris, 1923; London, 1948; Oberlin, 1956. *Ill.* Eric Newton, *The Meaning of Beauty,* London, 1950, p. 138; Trowell, pl. 23; Fagg 1953b, pl. 11; *BAMAM,* No. 19.

9-B. Wooden dance mask. This well known mask of the Guro tribe with its protuberant forehead and dished human face is surmounted by two forward jutting animal horns. A long-legged bird, apparently an ibis, balances itself on the horns. H. 20½". The University Museum.

> *Exh.* San Francisco, 1948. *Ill.* Wingert, pl. 25; Wieschhoff, fig. 14; Christensen, fig. 16.

9-C. Wooden heddle pulley, surmounted by a carved human head with a pigtailed coiffure. On the head is a bowl. The patina is a deep black and, where the nose was broken off, the scar itself is patinated. From the Fénéon Collection, Paris. H. 7". The British Museum, Webster Plass Collection.

> *Exh.* Paris, 1923; Paris 1936; Cambridge, 1948. *Ill.* Portier and Poncetton, pl. 48.

9-D. Wooden heddle pulley, topped with a carved Janus-head, well patinated, and with the wheel of the pulley missing. From the Fénéon Collection, Paris. H. 7¼". The British Museum, Webster Plass Collection.

> *Exh.* Paris, 1923; Cambridge, 1948

10. BAULE

The Baule are a large tribe of about half a million, closely related by language and culture to the Ashunti, their neighbors, although their sculpture seems more closely allied to that of their other neighbors, the Guro. Perhaps because their art is produced more for secular than for religious purposes, and because of their prosperous civilization which has had long contact with the French colonial administration, their work seems oversophisticated. This is one African tribe that produces art for art's sake and a well-to-do Baule man may have a number of carvings made purely for display, both figures and masks. The secret society plays little part in this tribe's life. Some of the charming figures are carved as "portraits" for friends and relatives of living people, others as representations of various gods and spirits, and others perhaps as ancestor figures. There is a great deal of copying and duplication

in Baule sculpture which makes for lack of originality in concept in the more modern work. They ornament their doors and shutters, their household artifacts, their drums and weapons with great virtuosity.

10-A. Wooden mask, probably made for display by a Baule art collector (the eyes are unpierced). It is in what may be called "classical" Baule style with neat well carved coiffure in three crests, the middle one rising in a curved pigtail, open mouth with bared teeth, mushroom beard and groups of scarifications at the temples. H. 20½". Mr. Frederick Pleasants, New York.
 Exh. Brooklyn, 1954; *Ill.* Brooklyn, No. 47.

10-B. Wooden mask representing an antelope head, with short spirally curved horns, somewhat human face and wide open square jaws with realistic tongue. The head opening is too small for wear by an adult—or even by a child, as has sometimes been suggested—and the piece is probably another specimen made for an art collector, or perhaps such masks have some totemic symbolism or personify a god. From the Fénéon Collection, Paris. H. 15½". The British Museum, Webster Plass Collection.
 Exh. New York, 1935; London, 1948. *Ill.* Sweeney, No. 84.

10-C. Wooden helmet mask, unusually large, representing a cow, to be worn horizontally with the dancer looking out through the mouth (cf. 10-D). It is a common type of mask among the Baule, and frequently used in dances to avert misfortune, or in funeral rites. H. 28". The University Museum.

10-D. Wooden seated figure, an elegantly sculptured female figure, probably an ancestor figure of importance, judging from its size and posture. But it may also have been carved for other purposes, even perhaps as a portrait of a living woman and her child. The tribal and clan markings are carved in high relief on the woman's face and body, and she is seated on a typical Baule stool. H. 15". The University Museum.
 Ill. Wieschhoff, fig. 17.

10-E. Wooden box with lid, a splendid example of a "Mouse oracle" of the Baule tribe, complete with the metal tongue and bead-tasseled straws for divining. The round box, decorated with three contrasting Baule masks in high relief, and with dentate bands at the base and top, has a braided hemp handle and a fastener of string and wood pegs for holding the lid closed when the mouse is at work. These oracles are commonly used by a village soothsayer for various divinatory purposes, to corroborate advice or foretell the future. The metal piece with the straws is placed in the bottom of the box, a lively mouse is introduced and the lid made fast. After a brief period, the lid is removed, the mouse jumps out and the diviner "reads" the decision of the straws, much as gypsies read tea leaves. H. 6¼". M. Charles Ratton, Paris.

★10-F. Wooden dance mask. This old mask with asymmetric coiffure, large heavy-lidded eyes (pierced for the dancer to look through), and small beard, braided into three strands, is patinated by use and rubbing until it is the color and texture of polished tortoise shell. H. 12½". M. Charles Ratton, Paris.
 Ill. Schmalenbach, pl. 38.

22

10-G. Wooden heddle pulley without the pulley wheel, with a detachable head in the form of a horned animal. The head is somewhat similar to 10-B and 10-C in miniature. H. 6″. The British Museum, Webster Plass Collection.

Ill. Fagg, 1953b, pl. 12e.

10-H. Wooden heddle pulley, complete with grooved nut for pulley wheel. An animal, perhaps a dog, surmounts the head that tops this carving. H. 7½″. The University Museum.

Ill. Wieschhoff, fig. 11.

★10-1. Wooden door. This house door opening on wooden turning sockets is decorated with a large female figure and two masks in relief are shown in the lower section. The sand-colored, very hard wood is of the type always used for Baule doors. H. 63″. Mr. Julius Carlebach, New York.

11. SENUFO

The Senufo, a large tribe living in the northern Ivory Coast, have a culture and art that is transitional between those of the Sudan and the Guinea Coast peoples. Their figure carvings, the finest of them, are among the best in Africa from the sculptor's standpoint.

★11-A. Wooden standing figure. Such very large sculptures from the Senufo are very rare and this piece, along with two others now in Swiss collections, was found by the lender, Mr. E. Storrer of Zürich, in the village of Lataha in the Senufo-Tyembara country. The trunk is worn with age and badly broken but the head retains a dignity and mystic beauty seldom seen in the carving of this tribe. H. 38½″. Mr. E. Storrer, Zürich, Switzerland.

★11-B. Wooden standing figure, a well-balanced carving of dark-colored hard wood, blackened by impregnation with oil and soot or black mud. The Senufo type of face, with forward thrusting jaw and receding forehead, the pointed breasts and belly are all decorated with incised radiating lines. The flexed knees balance with the pointed buttocks, and the heaped-up coiffure with pointed pigtails fore and aft add life and vigor to this fine piece. H. 20¼″. Mr. Eric Peters, New York.

11-C. Wooden standing figure. Dr. Kjersmeier has illustrated a similar piece from this tribe collected by him at Bobo-Diulasso, one of the Sudan's Bobo centers, as has Mr. F. Lem, who considers the piece he illustrated to have been made by the Bambara (although he found it among the Senufo). This piece is undoubtedly Senufo, and its notably monumental treatment in the placing of the cones of the face, breast, belly and knees, balancing similar forward-thrusting cones in the back, all decorated with the same radiating lines as 11-B, makes confirmation of its provenance quite definite. H. 11½″. Mr. Eric Peters, New York.

11-D. Wooden standing figure, collected on the expedition to the Ivory Coast headed by Dr. Vandenhoute and Dr. Maesen, then attached to the Musée

du Congo Belge and working at the University of Ghent. It was sent to Dr. Foley with some other pieces, after the expedition, in appreciation of his assistance. Small and delicately carved, it is akin sculpturally to 11-B. H. 7″. Dr. and Mrs. John Porter Foley, Jr., New York.

11-E. Wooden seated figure. This little seated woman may have been once the top of a staff, as 11-F. According to Dr. Kjersmeier, and as confirmed by Dr. Vandenhoute, such staffs, with iron ferrules, were set up in a field at seeding season and young men took part in hoeing competitions. The conqueror won the staff, had a good chance of a lucky marriage and had to give a celebration party for the other young men of the tribe. This carving was collected by Dr. Vandenhoute at Dembasso when he was making his study of the Dan Tribes and the Senufo H. 10¾″. Prof. Dr. P. J. Vandenhoute, Oostaker, Belgium.

11-F. Wooden staff, with a long iron ferrule, topped with a small seated female figure typical of those used in the hoeing contests of the youths of a village. The helmetlike coiffure, with pigtails, differs from the hairdress of 11-E, but in essential features they are very much alike—the prognathism of the jaw, the slim pointed breasts, the arms braceleted above the elbows and below, and the tribal marks on face and breasts. H. 55″. Mr. Eric Peters, New York.

11-G. Wooden door, carved and decorated, opening by means of a wooden socket and bolted with an Arab type of lock (see 1-H), said to be the door of a secret society house among the Senufo. Two typical Senufo flat masks decorate the top right panel, and other panels show conventionalized crocodiles, turtle, and birds, while the large section in the right central portion shows horsemen and various cryptic symbols. H. 48″. The University Museum.
Exh. Brooklyn, 1954. *Ill.* Wieschhoff, fig. 15; Brooklyn, No. 20.

11-H. Wooden dance mask. Such great masks, a synthesis of human and animal forms, with or without tusks, always have wide open, sharp-toothed jaws. They were called "Firespitter" masks, as, according to Dr. Albert Maesen, they were used by men of the Korubla secret society (firespitters) as protection against soul stealers and witches. The dances took place at night when tinder was placed in the great mouths and ignited, the wearer then blowing out sparks and flames. L. 31½″. Mr. Julius Carlebach, New York.

11-I. Bronze mask, cast in the style of the masks shown in 11-G, seems to have been designed for actual use and not, as in some other of these rarely seen bronze masks, merely for ritual use. A Senufo comb stands above the hairline and there are two incurving horns. H. 10″. M. Charles Ratton, Paris.

11-J. Wooden heddle pulley, topped with the head of a hornbill, originally collected by an expedition of the Musée de l'Homme. H. 6¼″. The British Museum, Webster Plass Collection.

11-K. Wooden male figure, differing from most African sculptures in its feeling of movement. It is said to have come from a sacred grove. The static quality of almost all tribal art is characteristic and traditional. Perhaps the mobile quality in this carving is accidental, but the carving of the legs and feet seems to

indicate that the man is walking. The sculpture was originally in the Paris collection of M. Charles Ratton. H. 30½″. Mr. and Mrs. Frederick Stafford, New York.

★11-L. **Wooden helmet mask.** Although the animal surmounting this mask is highly stylized cubistically, it is obviously a bull or a bull-buffalo. The small figures behind the animal's head are Senufo birds. The extra pair of horns (separately carved), rising laterally from the round helmet cap, balances this dramatic object in splendid fashion. A rather similar piece in this rare style was exhibited at Brooklyn, 1954 (*Ill.* Brooklyn, pl. 23). H. 23¼″. Mr. John J. Klejman, New York.

Exh. Oberlin, 1956. *Ill. BAMAM,* No. 9.

11-M. **Wooden helmet mask.** Although apparently carved as a model of one of the big "Firespitter" masks, this excellent carving is conceived on so big a scale sculpturally that one can scarcely believe that it measures only 9″ in length. Mr. John J. Klejman, New York.

11-N. **Wooden doll** wearing miniature mask, of the "Firespitter" type, said to be for children. H. 10½″. Miss Susanne C. Klejman, New York.

12. ASHANTI

The Ashanti are the dominant tribe of the Gold Coast and number some million and a half. They are organized into powerful city-states, and over-whelmed the earlier dwellers in the Gold Coast (such as the Bron) about three hundred years ago. They were a warlike people and created little representational art, their sculpture being related chiefly to the material apparatus of their Kings' and Queen Mothers' courts. In the Western world, their art is mainly known for the little brass or bronze weights used for weighing gold dust and nuggets before the introduction of coinage to their realm.

★12-A. **Brass weights** for weighing gold dust. These small human, animal and vegetable figures, cast by the same cire perdue process as the great court sculptures of Benin, possess a certain miniature charm and illustrate many of the customs, costumes, proverbs, artifacts, weapons, fruits and vegetables of the Ashanti. H. ½″ to 2″. Miss Susanne C. Klejman, New York.

Ill. Title page of this catalogue.

12-B. **Brass boxes** for holding gold dust and nuggets. Ashanti people who used gold carried their treasure in these small boxes, along with a small set of scales and the weights described above. L. 1¾″–2⅞″. Miss Susanne C. Klejman, New York.

13. BRON

The Bron (who founded the ancient state of Bono-Takyiman) were among the tribes conquered by the Ashanti when they overwhelmed the Gold Coast country. They seem to have had a real art tradition but their work is very seldom seen (or identified) in either museums or private collections.

13-A. Bronze mask, of human-animal form, excavated near Atabubu in the Gold Coast within the ancient kingdom of Takyiman. Perhaps it was buried with other sacred relics when the Bron were subdued by the fierce Ashanti. H. 7½″. The British Museum, Webster Plass Collection.

> *Exh.* London, 1949; London, 1951; Oberlin, 1956. *Ill.* Imp. Inst., 1951, pl. 29; Radin and Sweeney, pl. 109; Fagg, 1953b, pl. 18; *BAMAM*, No. 24.

14. DAHOMEY

The Kingdom of Dahomey, one of the most powerful city-states of Africa in the Middle Ages, was conquered by the French in 1872, when King Behanzin, the last of its long line of absolute rulers, was taken prisoner and banished from Africa. There is an oral history of this line of all-powerful kings going back some four hundred years (see Dahomey *by Dr. Melville J. Herskovits, New York, 1938, 2 vols.) and the kingdom continued to be strong and rich until the abolition of slavery in 1868. The slave trade was highly organized in Dahomey and not only were prisoners of war, criminals, unwanted children and the like, sold to the traders, but quite often members of the royal family who were troublesome to the king were shipped off to the New World with the slavers. Dahomeans helped to man the plantations of the West Indies, the Guianas, Brazil and even Louisiana. For centuries travelers told fantastic stories of the wealth and power of this kingdom; this was the land where the king had a mounted guard of fierce Amazon women, and had hundreds of wives and thousands of slaves. The art of the Kingdom of Dahomey was a court art; its purpose was to enhance the prestige of its rulers, and some of the most striking pieces taken from the Palace of Behanzin to Paris are curiously suggestive of the work of an African Fabergé, and bear little if any relation to the more plebeian arts of ordinary Dahomean ritual.*

★14-A. Wooden lion covered with leaves of silver, nailed on with silver nails. The base is of wood covered with fine yellow copper. This is a characteristic representation of the lion of Dahomey, the animal symbolising the King's majesty.

26

It is one of the great classical pieces of African art and has appeared in European exhibitions ever since 1923. L. 18¼". M. Charles Ratton, Paris.

 Exh. Paris, 1923; Brussels, 1930; Paris, 1931, etc. *Ill.* Portier and Poncetton, pl. 30; Basler, pl. 13b; Pijoan, vol. 1, pls. 306, 307; Underwood, 1949, pl. 62.

★14-B. **Wooden buffalo covered with leaves of silver,** fastened with silver clamps to the wooden sculpture. It has brass eyes and wrought iron horns and tail. This buffalo, also from the treasure of Behanzin, is by a different master from the sculptor of 13-A to judge by the method of applying the silver plating and numerous other technical details. L. 17¼". Mr. and Mrs. René d'Harnoncourt, New York.

★14-C. **Silver elephant.** Elephants have not been seen in Dahomey for many years; perhaps this most African in feeling of these three pieces from the Palace of King Behanzin was created by a man who had only heard about elephants from his elders. It is an elegant conception, and these three pieces, along with the famous and often reproduced large figures of M. Charles Ratton and the Musée de l'Homme, are among the few works of art still existing from this despotic and decadent empire of the past. L. 27¼". Mr. and Mrs. René d'Harnoncourt, New York.

15. YORUBA

The Yoruba are one of the largest of all African tribes and now number over five million. They are divided into many sub-tribes—the Ijesha, Egba, Oyo, Ijebu, Ekiti, Igbomina, etc.—which up until the last century were constantly waging war with each other but are now strongly and peacefully organized under the British Crown. There is such a stylistic uniformity about the art of these peoples that Yoruba carvings are perhaps more easily identifiable than those of any other African tribe. Art still flourishes in Yorubaland and here it is also possible to distinguish between the works of individual carvers, many excellent sculptors working in various centers up to the present day, in the old tradition, relatively uninfluenced by European concepts of art. The great cults and secret societies, common to all Yoruba-land—Shango, Eshu, Gelede, Egungun, Ogboni, Orishanla, etc.—are perhaps their art schools, with the carvers encouraged to work within the framework of their ancient traditions. The Yoruba of Owo, about sixty miles north of Benin, have a culture closely allied to the Bini, and many elements of Bini culture, particularly in wood and ivory carving, seem to be of Yoruba origin. The Yoruba of ancient Ife, the religious center of Yorubaland, founded a school of naturalistic bronze and terra cotta sculpture unsurpassed in Africa and from it the court of Benin drew its bronze casters before the arrival of the first white men in Benin in 1486. The Yoruba people occupy most of

27

the southwestern part of Nigeria and also parts of Dahomey, Togoland and the Gold Coast.

★**15-A. Group of small wooden standing figures,** called *Ibeji,* carved on the death of one or both of a pair of twins. They are washed and fed ceremonially by the mother of the dead, and kept by the surviving twin, if any, for his life, and then treasured in the family shrine. A string of cowrie shells on the left wrist signifies that the child has been dedicated to the cult of Shango. The quality of the beads worn about the neck gives some idea of the social status of the family. Each pair of *Ibeji* is originally carved with facial tribal marks, even if after years of handling and washing, these eventually disappear, along with the original blue (indigo) applied at the time of carving to the elaborate hairdresses and the reddish ochre to the bodies. Only the Yoruba carve *Ibeji,* and of the present group one pair, collected by Mr. Leon Underwood in 1946, is in the characteristic style of Ayo, son of Adugbologe, of Abeokuta, as is attested also by his "signature," a triangle incised on the base; others were collected at Oyo by Prof. W. R. Bascom, and one of these, in the carving style of the town of Shaki some distance to the north, is attached to the skull of a baboon, apparently because the child had been carried off by a baboon. H. 7½″ to 11½″. The American Museum of Natural History, New York; The British Museum, Webster Plass Collection; Mr. John J. Klejman, New York; Mr. and Mrs. James M. Osborn, New Haven.

 Ill. Fagg, 1953b, pl. 22, right; Y.U.A.G., pl. 61.

★**15-B. Wooden dance headdress** on a hollow hemispherical base, in the form of a rather prognathous human head with elaborately plaited coiffure. The face is colored yellow, the hairdress black. This type of headdress-mask is used by the Egungun society in its plays in honor of ancestors. H. 12½″. Mr. John J. Klejman, New York.

15-C. Wooden staff, in the form of a kneeling female figure holding a child on her back. It was probably made for the cult of Shango, the thunder god, and used by dancers seeking to become possessed. It conveys the idea of female service to the god, whose temples are always in the charge of priestesses. H. 16⅜″. Mr. and Mrs. René d'Harnoncourt, New York.

 Exh. San Francisco, 1948; Brooklyn, 1954. *Ill.* Underwood, 1947, pl. 19; Wingert, pl. 34; Brooklyn, No. 109.

15-D. Wooden dance mask, to be worn flat on top of the head in dances of the Gelede society, devoted to the welfare and increase of the community. These masks are always carved in pairs and a new pair is carved on the occasion of the death of any member of the society. They are brightly painted and vary in exterior design but not in essential shape. L. 13″. The University Museum.

15-E. Wooden box, representing a woman holding a lidded bowl in the form of a chicken. Such objects are used ceremonially for holding kola nuts offered to spirits (*orisha*) or to distinguished visitors. H. 17″. Mr. and Mrs. James M. Osborn, New Haven.

 Ill. Y.U.A.G., No. 63.

15-F. Wooden ceremonial mask, large Janus-faced type with superstructure bearing a horseman and attendant figures. These are used in the *Epa* festival once a year in Northern Yorubaland when young men, wearing these heavy masks, compete in leaping and dancing. *Epa,* an important god of the people of Iloffa district, was reputedly a great carver and at festivals honoring the god in order to bring fertility to the tribe and to the crops, it is thought fitting to have an exhibition of the finest mask carvings available. In former times the masks were hidden between ceremonies and were very highly valued. H. 49". The University Museum.

Exh. San Francisco, 1948; Brooklyn, 1954. *Ill.* Wingert, pl. 39; Wieschhoff, fig. 18.

15-G. Wooden ceremonial mask, large Janus-faced helmet type, with superstructure in the form of a tall standing woman who holds a short staff in one hand and a cloth in the other. Like 15-F, this piece was used in a festival of the *Epa* type in northeastern Yorubaland, and the two pieces together suggest the great variation of sculptural treatment permissible within quite a small area. H. 48". The University Museum.

15-H. Ceremonial axe, probably made for the Shango cult (see 15-C). The haft is carved in the form of a kneeling woman holding her breasts. L. 19". The British Museum, Webster Plass Collection.

★15-I. Brass staff, a ceremonial piece which was probably part of the regalia of a house of the Ogboni secret society. The staff has a Janus-head at each end, with all four faces identical; small brass rattles are attached to a series of rings around the heads and the staff itself is partly covered with a cast-in interlaced pattern. L. 14½". The British Museum, Webster Plass Collection.

Ill. Fagg, 1953b, frontispiece.

★15-J. Brass staff, one of a pair of staffs, usually male and female, called *Edan,* of which every Ogboni society house had one or more pairs for ritual use. There is a pear-shaped human head at one end with features cast in high relief, surrounded by scrolls, and four decorative crescents decorate each side of the staff, the bottom part of which has been broken away. This staff and 15-I were collected in Nigeria by Sir M. R. Menendez, the first Chief Justice of Nigeria, before 1902. In those days the Ogboni society was illegal and possibly these pieces were evidence against a house of the cult. L. 15". The British Museum, Webster Plass Collection.

Ill. Fagg, 1953b, frontispiece.

15-K. Wooden mother and child, a fine carving surmounted by the "double-axe" emblem of the thunder god, Shango. It may represent a priestess or devotee of the god. Although the style is suggestive of the northern Yoruba, the piece was collected in a village near the coast in 1946 by Mr. Leon Underwood, the English sculptor. The asymmetry of the sculpture is typical of the best Yoruba work. H. 27¾". Anonymous Collector, New York.

Exh. London, 1949; Brooklyn, 1954; Oberlin, 1956. *Ill.* Underwood, 1947, pl. 16, 17; *BAMAM,* No. 43.

★15-L. **Wooden ram's head** surmounting tapered cylindrical base, pierced at back for staff when in ritual use. This splendid piece is in the style of Owo though collected at Benin at the time of the Benin Expedition in 1897. H. 15″. The University Museum.

★15-M. **Wooden dance mask** for wear on top of head. It combines human and animal features and is ornamented with porcupine quills. From the back two snakes grasp a piglike animal in their jaws. The snout suggests a crocodile and the whole is painted black, red, yellow and blue in geometrical patterns. This is an Egungun Society mask, and another of exactly similar style has been photographed at Owo among the Ekiki Yoruba. L. 19″. The University Museum.

15-N. **Ivory rattle.** These rattles, called *iroke,* are shaken and their points tapped on the ground in Ifa divination rituals. The center portion of the slender tusk is carved in the form of a kneeling woman with her hands to her breasts. At the base of the tusk is the cross-hatched rattle with an ivory tongue. This piece is in the style of Owo, a town north of Benin, and was collected by Sir M. R. Menendez. L. 17″. The British Museum, Webster Plass Collection.

15-O. **Wooden equestrian figure,** representing a warrior. H. 11¼″. Mr. and Mrs. James W. Osborn, New Haven.

15-P. **Bronze human head,** with generalized features and wearing a flat open-work cap. This and the well known head in the Benin collection at Berlin (see Underwood, 1949, pl. 29) form a pair and are believed to have been collected at Benin by the 1897 Expedition. But like a number of the finest bronzes found at Benin they are far removed in style and spirit from the orthodox Bini work and may rather be attributed to the Yoruba, or possibly to the Igala of Idah on the Niger, who were likewise on the perimeter of the Benin empire. H. 6¾″. The British Museum, Webster Plass Collection.

 Exh. London, 1951; Brooklyn, 1954; Oberlin, 1956. *Ill.* Fagg, 1953b, pl. 24; Imp. Inst., pl. 14; *BAMAM,* No. 35.

★15-Q. **Bronze group,** representing two men in flat openwork caps and two elephants, cast on a rectangular base (8″ x 10″) with large opening in the middle. Like 15-P, this piece is probably of Yoruba manufacture, although no doubt collected at Benin and perhaps made for a Bini cult. H. 7½″. The University Museum.

15-R. **Ivory double armlet** with thin outer cylinder carved with human heads patinated to a fine golden brown, and inner cylinder perforated with small holes, the whole carved from a solid piece of ivory. Such armlets were part of the court costume and this is a particularly fine specimen. H. 5¼″. The University Museum.

16. BINI

The Bini people built up one of the great imperial powers of the African Middle Ages, their capital at Benin being a great city when described in 1668 by Dapper, who was impressed by its wide streets, its luxurious court,

its wealth and pomp, and its pagan religion involving human and animal sacrifices. The Bini have an oral history going back for eight hundred years at least, and their Obas or kings claim descent from the legendary founders of Ife, whence came, it is said, the first bronze founders who worked in Benin in the thirteenth century. The Benin Expedition of the British in 1897 resulted in the introduction of Benin art to Europe, but long before this the decadence of the Bini empire had begun and their later works are mechanical and unimaginative, being, like the art of the Ashanti and Dahomey, entirely devoted to the purpose of maintaining the prestige of the royal court. Some of the best sculpture found at Benin by the Benin Expedition was created by the Yoruba of Owo, who had many connections with Benin, and also by the Urhobo or Sobo, living on the banks of the Niger southeast of Benin, a tribe whose fierce warriors frequently fought as mercenaries in the armies of Benin.

★16-A. **Ivory double gong,** collected at Benin by Admiral Sir George Egerton, then Capt. Egerton, second in command of the Benin Expedition in 1897. Similar double gongs made of iron or bronze were also part of the royal regalia. This elaborately carved example was reputedly found in a chest of the deposed Oba, along with several of the famous ivory masks (see 16-B). In relief is a representation of the Oba with mudfish instead of legs, perhaps signifying relationship to Olokun, the sea god. Above the smaller gong is a carving of the Oba in his coral bead costume with his arms supported by two similarly clad courtiers. Various animals—crocodiles, birds, and bats—are shown and little free-standing figures clapping Benin-type cymbals stand at each end of the lip of both gongs. There is a rich golden brown patina to the old ivory (probably sixteenth century) and the object is a *tour de force* of the carver's art. It is said that the King of Benin, whose divine status among his people made his face so blinding that he appeared before them only when wearing a veil of beads over his face, could never laugh, nor even smile, so that when he was pleased with one of his subjects or with a tribute paid to him, he would signal the slave who stood beside him, holding a double gong before him, and the gong would be struck twice (the notes are a whole tone apart). These notes were known as "the Oba's laughter." L. 15". Mrs. Webster Plass, New York.
 Exh. Brooklyn, 1954. *Ill.* Brooklyn, No. 69.

★16-B. **Bronze pendant mask,** collected by Sir George Egerton. It is in a style rather frequently seen in Benin bronzes and is particularly notable for the beautiful expression of the face, which is akin to that of similar ivory masks. The tribal marks on the forehead are found on bronzes of the early middle period. H. 7½". Mrs. Webster Plass, New York.
 Exh. Brooklyn, 1954. *Ill.* Cover of this catalogue.

16-C. **Bronze pendant,** of a type worn in threes at the waistband of the kilt-like skirt of a Benin king or chief. There is a representation of the Oba with his

31

arms being supported by two courtiers in dress similar to the king's. This piece also was collected by Admiral Sir George Egerton on the Benin Expedition. H. 7½". Mrs. Webster Plass, New York.

Exh. Brooklyn, 1954. *Ill.* Brooklyn, No. 71.

16-D. Bronze pendant mask, in the form of a leopard face, as worn by chiefs on the left hip (see 16-E). H. 6½". The British Museum, Webster Plass Collection.

★**16-E. Bronze figure of a man blowing an ivory horn,** a magnificent sculpture in the round and one of the finest of all Benin works. Although such pieces were found on the royal altars, they also very probably had the purpose of glorifying the Oba as a man of many attendants. It can be observed that the hornblower is wearing a small pendant mask (similar to 16-D) where his skirt is pleated and knotted over his left hip. H. 24⅝". Mr. and Mrs. R. Sturgis Ingersoll, Philadelphia.

16-F. Bronze human head of naturalistic form, probably representing a dead Oba. It is very thinly cast like other heads of this realistic type, the thickness hardly exceeding 1 millimeter in most parts. Such heads are believed to be the earliest surviving works of Benin and to date from the fifteenth century. According to one tradition at Benin, they were actually made at Ife in Yorubaland before bronze-casting was introduced from there to Benin, but this seems unlikely on stylistic grounds. This example of the early period may be compared with 16-G representing the middle and 16-H representing the late periods of Benin art history. H. 8¼". The University Museum.

Exh. Brooklyn, 1954. *Ill.* Brooklyn, No. 68.

16-G. Bronze human head, a good example of the heavier type of head, following the earlier, thinly cast ones. It was made perhaps in the seventeenth century. The Oba is wearing a high choker necklace and cap of red coral beads (similar regalia is displayed at the British Museum) and there are the three Bini tribal marks over each eye. H. 11". The British Museum, Webster Plass Collection.

Exh. London, 1949; London, 1951; Oberlin, 1956. *Ill.* Underwood, 1949, pl. 30; Fagg, 1953b, pl. 25; *BAMAM,* No. 28.

16-H. Bronze human head with tusk. Similar to 16-E, but with bronze "wings" added to the head, it is shown with the tusk in place as such pieces were found on the altar of the Oba's ancestors in the palace courtyard. The ivory tusk is carved with portraits of Obas, symbolic and mythological animals, and other signs and portents. The flamboyant type of headdress shown in the bronze is said to have been introduced by the Oba Osemwede (1816-1848). This is a fine example from the decadent period of Benin art. H. 18¾". The University Museum.

Ill. Wingert, pl. 41.

★**16-I. Small bronze human head,** probably representing an Oba. With the exception of a still smaller piece in the British Museum, this is probably the smallest Benin bronze head known. The coiffure and four flaring linear marks

on each cheek associate it with some pieces of the early period, but the tribal marks on the forehead are transitional between those of 16-F and 16-G, and the head may be assigned to the end of the early or the beginning of the middle period. H. 4¾". Mrs. Webster Plass, New York.

Exh. Oberlin, 1956. *Ill. BAMAM,* No. 29.

16-J. Four bronze rectangular plaques. Such plaques as these in early days covered the mud pillars of the royal palace, during the seventeenth century, but when the British arrived on the expedition, they were found piled in a disused part of the palace precincts, whence most of them were removed to London, and later distributed to many museums and private collections, the British Musem alone having some two hundred of them. These four represent severally an Oba with attendants; two standing figures, of which one holds a box in the form of a cow head; a naked boy holding a cylindrical box; and a figure holding an annular ivory box. Hs. 18", 19", 20", 20". The University Museum.

Ill. Wingert, pl. 42.

16-K. Ivory cup, supported by four human figures in varying costumes, one of the best pieces of African ivory carving in America. One of the men is wearing a cross around his neck as a pendant, possibly representing a courtier of the Oba who was converted by the Portuguese missionaries of the sixteenth century when, for about a century, many Bini became Christians, afterwards reverting to paganism. H. 7¾". The University Museum.

16-L. Carved ivory figure of a standing woman, found at Benin, and in an excellent state of preservation. Female figures are seldom represented by Bini carvers; this may be a queen mother of the early nineteenth century. H. 15". The University Museum.

16-M. Carved ivory box of oval shape with cover depicting a fight between two Portuguese in sixteenth-century dress (though the carving is probably of much later date), with a gin bottle flying through the air and a tethered pangolin coiled in rings and pegged down by his tail. African carvers seldom sculptured faces in profile; this strange conception shown in the heads of the Portuguese is reminiscent of an Ethiopian convention. The sides and base show the typical Bini interlacings. L. 6½". The University Museum.

17. KALABARI IJO

The Ijo may be divided into an eastern group (the Kalabari clan) and a more varied western group. They live along the swampy creeks of the Niger Delta, building their huts over the mangrove roots. It is believed that they were forced to flee into this unhealthy part of Nigeria by successive waves of Yoruba and Bini invaders. They are still a primitive society, living by fishing and agriculture and their dominant secret society is largely concerned with Owu (water spirits) and the fertility of the tribe.

33

★17-A. Wooden dance headdress, a hippopotamus mask, used in a play-cycle organized by the Sekiapu society that may last as long as a quarter of a century, concerned largely with the various *Owu,* of which spirits the hippopotamus is one of the most important. Like all Ijo masks, this blackened and cubistic mask should be worn horizontally on top of the head. The mask was collected in the Niger Delta among the Kalabari clan by Amaury Talbot, who describes these dance-plays in his *Tribes of the Niger Delta.* L. 18½″. The British Museum, Webster Plass Collection.

 Exh. London, 1948; London, 1949; London, 1951; Brooklyn, 1954; Oberlin, 1956. *Ill. BAMAM,* No. 40.

17-B. Wooden dance headdress for wear on the top of the head as in 17-A. It takes the form of a stylized human face and is heavily patinated with a grayish substance, probably sacrificial matter. It was also used in plays about the *Owu.* Collected by Amaury Talbot among the Kalabari, it was exhibited with 17-A at the same exhibitions. L. 11½″. The British Museum, Webster Plass Collection.

 Exh. See 17-A. *Ill.* Fagg, 1953b, pl. 26, above; *BAMAM,* No. 41.

17-C. Wooden headdress mask, bearing two stylized heads back to back, feather-trimmed, worn as a cap laced to the head and neck of the wearer through the holes in the circular base. The style is that of the western Ijo. H. 30″. The Peabody Museum, Salem, Mass.

 Exh. San Francisco, 1948. *Ill.* Wingert, pl. 48.

★17-D. Wooden figure, kneeling with bowl, a rare and powerful sculpture. It seems probable that it adorned a shrine and that the bowl was used for offerings —cowrie shells, fine beads, perhaps feathers or bits of mirrored glass. The figure is, most unusually, carved from red camwood (probably *Pterocarpus* sp.). It appears to be in the style of the western Ijo, or possibly of the Urhobo. H. 26¼″. Anonymous Collector, New York.

18. IBO

The Ibo are a large tribe of some five million population. They are divided into many groups or sub-tribes and do much trading with their neighbors along the Cross River, the Ibibio and Ekoi. Their sculpture shows a wide variety of apparently unrelated art forms, but they speak a common language; they have several powerful secret societies.

★18-A. Wooden figure carved in hard wood and polychromed. Each Ibo man of the Onitsha region owns one of these carvings, called *ikenga* (roughly translated as "right arm"), ranging in size from a small platform of wood with two horns about four inches high to elaborate structures of human size, depending on the importance of the owner. The horns are the important part of an *ikenga,* embodying the owner's personal good luck, and these carvings are consulted and propitiated with offerings before important decisions are reached by a family.

34

H. 14½″. The Yale University Art Gallery, Linton Collection.
 Exh. New Haven, 1954.

18-B. Wooden figure carved in hard wood. An *ikenga* more simple in conception than 18-A and uncolored. H. 11½″. Baltimore Museum of Art, Wurtzburger Collection.
 Exh. Baltimore, 1954. *Ill.* Baltimore, pl. 6.

18-C. Wooden dance headdress, from the Bende Division of Iboland and typical of those worn by men in the *Ogbom* dance in honor of Ala, the earth deity, who is believed to promote tribal fertility. The figure originally had a woven basket base which fitted the wearer's head like a cap held in place by heavy twine passed through the hole in the base and under the dancer's chin. *Ogbom* (sometimes called *Obobom*) is danced after the New Corn Feast in June and July by all the villagers, but only men wear these headdresses. The Ibo share this dance with the Ibibio, and this mask was reputedly carved by an Ibibio sculptor for the Ibo village of Ozuitem. The piece was collected by Dr. Jack Sargent Harris during a year's anthropological study of this tribe before the Second World War and was said at that time to be "very, very old." H. 24″. The Yale University Art Gallery, Linton Collection.
 Exh. San Francisco, 1948; New Haven, 1954. *Ill.* Wingert, pl. 47; Y.U.A.G., No. 71.

★**18-D. Mask** of light wood, in three-quarter profile, is one-third of a trifacial helmet mask from Ozuitem and was reputedly brought from the Ibibio side of the Cross River. It was last used in 1917 in the *Ikem* play-dance, and the remainder of the mask still hangs in the Men's House in Ozuitem, according to Dr. Harris (see under 18-C) who saw it there in 1939. After he had vainly tried to buy it for more than a year, it was presented to him by the elders of the tribe in appreciation of his help in a land dispute. H. 23″. Mrs. Webster Plass, New York.
 Exh. Brooklyn, 1954; Oberlin, 1956. *Ill.* Brooklyn, No. 86; *BAMAM,* No. 39.

★**18-E. Wooden dance mask.** This polychromed mask of soft wood, called *Maji,* is worn only at a festival held every three years celebrating the completion of the boys' initiation rites, their graduation from the "Bush University." The scimitarlike crest represents the special ceremonial knife used to cut yams at the New Yam ceremony; the cylindrical prongs represent teeth. The mask is sewn on a woolen cap and worn with a costume of cloth from waist to knee, and bell-trimmed straps crossed on the chest. Collected by Dr. Harris in 1939 at Amaseri. H. 13″. Mrs. Webster Plass, New York.

18-F. Wooden dance mask, highly polished, of light color, used for the *Eru* dance of the Ekpa society. Ekpa, a non-secret society, is widespread in Iboland, and has a small initiation fee which goes to buy palm wine and an animal for barbecue in its special festivals. It functions as a work society and a money-lending agency and is highly beneficent. Dr. Harris reported that this mask was bought from an Ibibio slave market between 1895 and 1900. H. 9″. Mrs. Webster Plass, New York.

18-G. Wooden crested mask, said to represent a maiden spirit. It was painted white and worn by members of the powerful Mmo or Mau secret society, with a tight-fitting costume of gorgeous color decorated with appliqué secret symbols. The dance is given at communal festivals of the society and particularly at funerals of members. H. 17½". The University Museum.

Exh. San Francisco, 1948. *Ill.* Wingert, pl. 45; Wieschhoff, fig. 19.

19. IBIBIO

The Ibibio speak a different language—semi-Bantu—from the Sudanic-speaking Ibo, but they borrow artistic forms from each other in connection with their secret societies, in some cases common to both, and live in the Cross River region of southeast Nigeria.

19-A. Wooden dance mask in the form of a wedge-shaped human face surmounted by a pair of forward-curving horns. It has been elaborately poly-chromed and its lower jaw was carved separately and is articulated so that the wearer can make a clacking noise with it. The Ibibio tribal marks in front of the ears and above the nose are in high relief. These masks are used in ritual dances of the Ekpo secret society of the Ibibio, which exists for the propitiation of ancestor spirits and to maintain social order in the community. Formerly any non-member who witnessed the Ekpo rituals was killed. H. 13". The British Museum, Webster Plass Collection.

Exh. London, 1949, 1951; Oberlin, 1956. *Ill.* R.A.I. 1949, pl. 16; Fagg, 1953b, pl. 28; *BAMAM,* No. 36.

★**19-B. Wooden dance mask** with articulated lower jaw. This large mask, stained black and polished, is apparently grinning. The filing of the front teeth is a tribal characteristic. The raffia "hair" is still intact with other fittings and twines for actual wear. This example was probably used, as was 19-A, for Ekpo rituals. H. 28". Mr. Julius Carlebach, New York.

19-C. Wooden dance headdress covered with animal skin. During use in the *Ogbom* dance-play (see 18-C) the wool of a ram is fastened to the back of the head and the headdress is fastened to a basketlike cap which is tied under the chin of the wearer. H. 22". Mr. Eliot Elisofon, New York.

Exh. Brooklyn, 1954. *Ill.* Brooklyn, No. 93.

19-D. Wooden standing female figure, of light wood, painted white with "secret" asymmetric markings in black. The small arms are carved separately. The high crested coiffure, painted black, is elaborately decorated with European pearl buttons instead of the usual cowrie shells and a necklace of carved leopard teeth is worn showing the high standing of the ancestor represented by the figure. Bought in England from the family of a missionary who collected the piece in the Ibibio country in the 1890's. H. 24". Mrs. Webster Plass, New York.

19-E. Wooden dance mask, stained dark brown and polished. The distorted features and nose possibly represent deformation by syphilis; the mask is used in

36

Ekpo secret society rites. See 19-A. H. 12½″. The Baltimore Museum of Art, Wurtzburger Collection.

Ill. Baltimore, pl. 52.

20. EKOI

The Ekoi are a small tribe of the upper Cross River living near the Ibo and Ibibio. Their naturalistic carved heads, either carved as helmet masks or fastened to basket caps to be worn on top of the head, are almost always skin-covered. The hide used is usually that of a small antelope but possibly in earlier times they were covered with human skin. Carved human figures are found only at rare intervals among this tribe.

20-A. Wooden dance headdress surmounted by three long spiraled black horns. This Ekoi (or Efik) example is used in elaborate dances on great festivals by the Ikem secret society, composed of both men and women. The headdresses are meant to be very impressive and to enhance the society's prestige. H. 26″. Mr. Julius Carlebach, New York.

★20-B. Wooden dance headdress. Unusually small, it varies from the usual realistic Ekoi mask in its prognathous, duck-billed jaw and elaborately painted designs. It was also probably used in Ikem society rituals and dances. H. 8¾″. Mr. Julius Carlebach, New York.

20-C. Wooden figure. This very much worn piece is difficult to identify, but there is a suggestion of the Cross River about the form and the tribal marks; it may well be from the Ekoi, and if so it is an example of their seldom seen carved human figures. It belonged to Picasso from 1919 to 1932, when he gave it to his friend, Jean Cocteau. H. 13¾″. Mr. Eric Peters, New York.

21. MANGAM

The Mangam are a small pagan tribe near Wamba in Northern Nigeria, who make fine red-colored bovine and antelope masks for their own use and that of some neighboring tribes, such as the Mama and Kuleri; their art has been studied by Mr. Kenneth Murray and Mr. Bernard Fagg of the Nigerian Antiquities Service, but is scarcely represented in European or American collections, and probably never by documented pieces. These masks are used in dances of the Dodo or spirit society.

21-A. Wooden dance headdress, probably representing a buffalo, to be worn on top of the head. This well-known piece, formerly in the possession of the late Mr. W. O. Oldman of London, was attributed by him to "the Okuni, Northern Nigeria," but no such tribe or place can be traced there, and the carving is

a typical and fine example of the Mangam style. L. 14″. M. Charles Ratton, Paris.

> *Exh.* New York, 1935; London, 1951. *Ill.* Sweeney, No. 306; Imp. Inst., 1951, pl. 24; Radin and Sweeney, pl. 13.

22. TRIBES OF THE CAMEROONS GRASSLANDS

The Cameroons Grasslands culture, partly under British and partly under French trusteeship, comprises a number of small, rather similar tribes. Their art styles have not been sufficiently studied in the field to make very sure distinctions between them, and it seems that their basic homogeneity is accompanied by a marked cultural interdependence among them, one tribe casting brasswork, another making pottery tobacco pipes, etc. Most of their woodcarving is of unusually large size and boldly conceived, and the houses of their chiefs and great men are decorated with carved door-posts and lintels.

★22-A. **Wooden dance mask,** large polychromed helmet-type, showing an apparently grinning human face with protruding ears. It is surmounted by a headdress of rectilinear shape carved with a series of spiral shells. This piece is possibly Bamileke from near Fumban in the French Cameroons. H. 29″. M. Charles Ratton, Paris.

> *Exh.* New York, 1935.

★22-B. **Wooden figure of a man.** This majestic figure from the Bangwa, described as "figure of a king," is covered with a thick patina, perhaps an incrustation of blood or other sacrificial matter. H. 39¾″. M. Charles Ratton, Paris.

22-C. **Wooden dance mask** in the form of a stylized cow's head, the hard wood polished to a dark brown color. H. 24½″. Mr. Julius Carlebach, New York.

22-D. **Brass pipe bowl.** The stylized elephant's head which forms the bowl of this pipe is a form often used in the Grasslands by the brass-casters of the Bali tribe. L. 7″. Mr. John J. Klejman, New York.

22-E. **Wooden stool** with back of female figures, made of hard wood, perhaps coming from the Bamum. H. 31½″. Mr. Julius Carlebach, New York.

22-F. **Wooden head** with long neck which flares towards the base. Perhaps from the Bamum. H. 18″. Mr. Albert Duveen, New York.

22-G. **Wooden figure** of a man with flat square head, standing with the angular left arm touching the right arm. It is stained black. The position of the arms and the upward slanting eyes indicate that it belongs to a minor style of the Bamenda district. H. 10″. The British Museum, Webster Plass Collection.

22-H. Beaded wood fly-whisk. While not really a work of art, this object is included in the catalogue because it is an example of Cameroons beadwork and is complete even to the monkey-hair whisk attached to the back of the carved and beaded ram head. Whole figures are covered with beadwork similar to this at times; stools and ceremonial objects of all kinds are trimmed with it. L. 47" (including the whisk itself). Mr. Julius Carlebach, New York.

22-I. Wooden door lintel, originally carved for a chief's house, adorned with naturalistic nearly life-size monkeys. It reflects the exuberance and imaginative realism especially characteristic of the Bamileke style. L. 7'1". The University Museum.

23. KUYU

Not very much is known about the Kuyu tribe, an inland people living near the Congo River in the French Congo. Their wooden heads are carved as one with the long tapered cones which they surmount. Except in the older specimens (such as are shown here), they have no great artistic merit. Their figures are much more rare than the heads.

★23-A. Wooden Janus-figure. This unique figure represents a male and female figure back to back. It is polychromed in red, violet, and white and was acquired from a colonial administrator in the Fort Rousset region of the French Congo. It is one of the few Kuyu carvings of real artistic merit. H. 32". M. Charles Ratton, Paris.

23-B. Wooden head on cone, typical of one of the heads carried aloft by dancers, much as a torch might be held up in a tribal dance. The dancers wear a concealing cloak of dried grasses. H. 10¾". Mr. John J. Klejman, New York.

23-C. Wooden head, similar to 23-B, but lacking the pointed end of its cone. This head is unusually well and naturalistically carved. H. 18¾". M. Charles Ratton, Paris.

23-D. Wooden figure whose black color has been acquired over a long period of time; originally it must have been brilliantly polychromed as are all Kuyu figures. H. 22". Mr. Julius Carlebach, New York.

24. BAKWELE

The Bakwele, living in the upper Sangha area of the French Congo, are a little-known tribe of whose artistic production only a dozen or so fine masks exist in the museums and private collections of the world.

★24-A. Wooden dance mask. An imaginatively simplified animal mask, with human features framed by the free-standing horns paralleling the face. Its patina shows that it was once colored with some reddish pigment. H. 24". M. Charles Ratton, Paris.

24-B. Wooden dance mask. The long snakelike nose of this mysterious animal mask may indicate that it represents a demon. Bakwele masks on the reverse usually have carved in them a shallow depression where they fit on the head. H. 30⅛″. Anonymous Collector, New York.

★24-C. Wooden dance mask. The use of this mask (and that of 24-A) is unknown, but its imaginative simplicity and plastic vitality make it great art. H. 20½″. Anonymous Collector, New York.

★24-D. Wooden dance mask, nearly circular, with heart-shaped concave face, in which the Bakwele style is reduced to its simplest essentials, while retaining great directness of expression (like the Warega style of the northeastern Belgian Congo, which it superficially resembles). H. 11″. Mrs. Webster Plass, New York.

25. BABANGI

The Babangi people live on the west side of the Congo River, extending up the basins of its tributaries, the Sangha and the Likuala. They are fishermen and traders living in huts built high on piles along the muddy, often high-swollen streams. There is a fair amount of ethnographical material in the museums of the world from the Babangi—fish-nets, fish traps, fish spears, knives, clubs, small articles of personal adornment—but little evidence of any original sculpture belonging to these people. See Siroto's article for a comparative study of the two masks shown here, which he attributes to this tribe.

★25-A. Wooden mask from Etumbi, a village of the Mboko, one of the westernmost of the Babangi tribes. This mask, with its long heart-shaped face and protuberant forehead, is often compared to Picasso's *Les Demoiselles d'Avignon* because of the resemblance between this mask and the demoiselle on the right side of the painting, which was one of the first belonging to Picasso's Negro period. H. 14″. The Museum of Modern Art, New York.
> *Exh.* New York, 1935. *Ill.* I.C.A., p. 18 (along with detail of the Picasso *Demoiselles*); Siroto, pl. J; frontispiece of this catalogue.

★25-B. Wooden mask of light tan color, rubbed with chalk or similar substance. It is slightly less naturalistic than 25-A differing from it in its protruding, square-socketed eyes and its color, as well as in its bolder execution. It is from the Likuala section of the Babangi, a small group living in the eastern part of the Babangi country. H. 14½″. The Brooklyn Museum, Brooklyn.
> *Exh.* Brooklyn, 1954. *Ill.* Brooklyn, No. 198; Siroto, pl. J; frontispiece of this catalogue.

26. BAKOTA

The Bakota are a group of tribes who live mostly in the Gaboon and the Moyen Congo. A recent authoritative study has been made of this tribe

by E. Andersson in which most aspects of their culture are covered (see Bibliography). Hitherto this group has been little known except through the presence of a large number of their characteristic brass-plated figures.

★**26-A. Wooden half-figure on stool.** The coiffure in three parts, the concave face, the arms akimbo and the typical Bakota stool relate this piece surely to the frequently seen funerary figures plated with brass and copper. But it is unusual to find figures in the round produced by the Bakota, so this may possibly be an old piece from which we can trace the transition to the flat forms of funerary figures. H. 22½". The University Museum.
Exh. Brooklyn, 1954.

26-B. Wooden composite human figure with face overlaid with brass and copper sheeting. It is of the older type with quarterings of the face covered by narrow parallel strips of copper and iron, instead of brass on which lines have been scored. On the back of the head is a wooden lozenge in low relief. The half body may represent arms akimbo. These plated figures, known as *mbulu-ngulu,* are fastened to the tops of round baskets that hold the bones of ancestors, usually the skull, and are said to be kept in family shrines. H. 26". The British Museum, Webster Plass Collection.
Exh. London, 1948. *Ill.* I.C.A., 1948, p. 16.

★**26-C. Wooden composite human figure** overlaid with brass and copper sheeting as 26-B. Although superficially these two pieces seem much alike, this face shows a round mouth and well arched brows and the face is convex, which is believed to represent the spirit of a male ancestor, whereas the concave 26-B is female. This and 26-B were acquired by M. Charles Ratton at about the same time. H. 26½". M. Charles Ratton, Paris.
Ill. Schmalenbach, pl. 83.

26-D. Wooden composite human figure overlaid with metal plating. This much smaller figure is in excellent style and is of particular interest for the carving on the back of the head. H. 12½". Mr. John J. Klejman, New York.

★**26-E. Wooden composite human figure** overlaid with brass and copper sheeting. This funerary figure is known as Ossyeba, possibly because the first recorded figure like it (at the Musée de l'Homme, Paris) was from the village of Ossyeba in the Gaboon. The figure is unusual in that the back is decorated as well as the front, indicating perhaps that it was not meant, as were 26-B and 26-C, to be viewed entirely from the front. The headdresses of Ossyeba figures are markedly different from the *mbulu-ngulu* types and the strips of brass or copper are applied horizontally around the head. H. 24". Mr. and Mrs. Frederick Stafford, New York.
Exh. Brooklyn, 1954; Oberlin, 1956. *Ill.* BAMAM, No. 48.

27. BALUMBO

The Balumbo are a large coastal tribe of French Equatorial Africa related to other small inland tribes along the Ogowe River. They are best known in museums and among collectors for their realistic facial masks of a rather oriental type, which are used in stilt-dances commemorating the spirits of dead women. The masks are almost always colored white for the dances, white being the color of death among some African tribes. Few of the masks are closely documented, though they seem to belong to the Mukui Society; they are variously attributed to the Balumbo, M'Pongwe, Ashira, Mashango and Bakota. Figures carved in the round are seldom found except for small amulets such as 27-B.

★**27-A. Wooden dance mask** used by men in funerary dances commemorating the spirits of dead women. It has lozenge-shaped groups of cicatrizations on forehead and temples and the characteristic quadripartite coiffure. H. 11½". Mr. Eliot Elisofon, New York.

27-B. Wooden figure in the form of a kneeling woman with long pointed coiffure like the beak of a bird. M. Charles Ratton considered this small piece a hook, the long chignon being hooked into the belt and the object to be hung from it being fastened with a string through the hole pierced through the legs. There is also a hole through the coiffure, giving this piece in profile the look of a bird's head with the hole for an eye. H. 3½". The British Museum, Webster Plass Collection.
Exh. Cambridge, 1948.

28. FANG

The Fang, a large tribe of the French Gaboon and Spanish Guinea (Rio Muni), are also known as the Pangwe and the Pahouin. But by any name they are recognized to be among the finest of Africa's sculptors. Their religion seems to be related to the neighboring Bakota and their principal artistic production is ancestor figures which are mounted over bark boxes which hold the skulls and sometimes other relics of ancestors. Some of their figure carvings and heads have been dated by evidence as far back as the eighteenth century, making them, with some of the Bushongo carvings, the oldest wooden sculptures in Africa. Most of the Fang sculpture shown in this exhibition is intended to be shown with the skull boxes, as proved by the long stalk of wood carved downward from the coccyx. These stalks are intended to hold the seated figures firmly to the rim of the skull boxes. The Fang style is characterized by a round head, an often coif-like hairdress, a

long simple body with the arms held away from the sides and joined in front where the hands often hold a staff or horn for magical substances, and short bulbous legs. The eyes are often inset with metal discs, sometimes bases of cartridge cases. Most Fang pieces are blackened, and many still exude an oily substance, as does 28-A. Often as many as three skulls are found in the cylindrical bark boxes, so it might seem that the sculptures may represent the spirits of more than one ancestor (though according to some reports they are not representative at all, but simply apotropaic). The skulls are sometimes rubbed with tukula powder (powdered camwood) to give them a rosy appearance.

28-A. Wooden figure. This female ancestor-cult figure has been treated with an oily substance, blackening the pendulous breasts. The tripartite and typically bobbed coiffure is highly stylized and the eyes are inset with brass discs. H. 19½″. Mr. and Mrs. Frederick Stafford, New York.

28-B. Wooden figure, male, one of the great classical pieces of African art. It is bearded and the hands hold a staff or medicine horn before the body. The cylindrical navel protrudes from the slim long cylinder of the body and the bulbous little legs have inward pointing knees. Eyes and navel have brass discs appliquéd. H. 23″. Mr. James Johnson Sweeney, New York.
> *Exh.* New York, 1935. *Ill.* Einstein, pl. 40; Sweeney, No. 322; Radin and Sweeney, pl. 68.

★28-C. Wooden figure. The long tasseled coiffure, the carved necklace, and the sharply conical breasts differentiate this female figure from the two described above. It has the natural dignity of all Fang ancestor-cult figures. The excellent patina is dark brown in color and highly polished. H. 17½″. M. Charles Ratton, Paris.

★28-D. Wooden female figure of classical Fang style. The eyes once had metal discs applied to them. The small rounded breasts show signs of damage, possibly by fire, which destroyed the left and most of the right arm. The flexed legs are typical and well modeled. Formerly of the Guillaume and Derain Collections. H. 21″. Prof. Nelson Goodman, Philadelphia.

28-E. Wooden human head with long cylindrical neck. A bound coiffure holds the hair back from the high rounded forehead of the sensitive oval face. The neck acts as the stalk to hold the head firmly to its reliquary. A rectangular scar on the forehead shows where metal may have been appliquéd as it is to the eyes. H. 12½″. Mr. Frederick Pleasants, New York.
> *Exh.* Brooklyn, 1954. *Ill.* Brooklyn, No. 207.

28-F. Wooden human head with diagonally bored holes through the long neck for attachment to harp. Such heads as these were fastened to the upper part of Fang harps with strong cord and may have faced the harpist when he strummed his instrument. H. 9″. The University Museum.

28-G. Wooden human head, possibly harp head. Although collected by Frobenius and attributed to the Bushongo, this head is certainly from the Fang. It may have been used as a harp head although the neck is not pierced for attachment but has a narrower projection below. H. 13¾". The University Museum.

28-H. Wooden dance mask, painted white, with vegetable fiber beard. Such dance masks as this are widely used by various Gaboon tribes and this is probably from the Fang. H. 18". Mr. M. L. J. Lemaire, Amsterdam.

★28-I. Wooden figure, female, of somewhat unusual type, carved from light brown wood and rubbed with chalk or kaolin. The short arms are joined over the breasts (which are not indicated), and on the lower part of the long torso are carved two areas of asymmetrical incised decoration. The highly stylized short legs have been colored black, as have the arms and the coiffure. There is no stem for attachment to the skull box (see 28-A to D) and this sculpture may therefore have served some other purpose. It was collected by a missionary in the nineteenth century and given to the Museum in 1901. H. 31". The University Museum.

29. BABWENDE

The Babwende are a not very large tribe living on the east bank of the Congo River not far from the sea, close to the Bateke and the Bakongo. They are best known in the museums for the small human figures they carve, often called Sibiti after a village of theirs by that name from which these carvings are frequently collected. The small sculptures are used by the Babwende much as were the Lares and Penates of the Romans—as household gods in family shrines. The elaborate cicatrization on the trunk (which seems in many cases to have been lengthened to contain all these elaborate weals) is said to be the "family tree" of the owner. The Babwende carve a few larger figures in the same style. They also make enormous stuffed cloth figures (niombo) *as coffins for the dead, and it has been suggested that the form of these may have influenced a few of the woodcarvings.*

29-A. Wooden figure of a woman standing with her hands on her cicatrized abdomen. The coiffure is asymmetrical, the ears are pierced with long pins and the eyes are inset with bone. In the lumbar region there is a deep tubular hole bored in which magic substances were placed. The owner of this piece picked out the magic bits, small scales that might have been of lizard or snake and a plug of dried vegetable substance, probably grass. This piece was formerly in the Felix Fénéon Collection in Paris. H. 7". The British Museum, Webster Plass Collection.
 Exh. Oberlin, 1956. *Ill. BAMAM,* No. 57.
29-B. Wooden figure. This burly little bull-necked male figure with wide

square shoulders and oversized hands held before the abdomen is a variation on the better-known theme of 29-A. The cicatrization of the body is more widespread; there is a pleasant design on the back and the upper arms show weals of concentric circles. The eyes are similar to 29-A's, but the ears are unpierced. Mr. William Fagg has suggested that this and two other related pieces may have been influenced—particularly as to the peculiar form of the shoulders and hands—by the *niombo* cloth figures referred to above; if this is so, it may be surmised that these pieces (as distinct from the "Sibiti" figures) are ancestor figures. H. 9¼". The University Museum.

Ill. Schmalenbach, pl. 141 (and compare pl. 142 and *BAMAM*, No. 56).

30. BATEKE

The Bateke live both in the French and the Belgian Congo, mostly just north of Brazzaville. They are best known for their fetish figures, often found so wrapped in magical substances and cloths that the carving is not visible except for the head. Bateke figures may always be identified by the groups of parallel vertical scarifications on the cheeks. Their work is seldom of high artistic quality.

30-A. Wooden figure, a standing fetish, probably male, is elaborately dressed in cloths and hung with various amulets and charms of snake and lizard or little packages of unknown matter. The fine carving of the noble head with its carefully stylized beard and hairdress, however, entitle it to representation in this exhibition. H. 23½". Mrs. Webster Plass, New York.

30-B. Wooden figure. In contrast to 30-A, this standing male figure, although well treated with tukula powder, better illustrates the Bateke style of carving the body, as all the magical materials have been removed from the slim and geometrical figure. In the lower back there is a cavity for holding "medicine" with a rectangular opening covered with a broken lid. H. 12". Mr. and Mrs. E. Clark Stillman, New York.

31. BAKONGO

The Bakongo, a large tribe living along the lower reaches of the Congo River, produce the most naturalistic sculpture in the Congo, owing perhaps to the fact that European missionaries and traders lived among these people as early as the sixteenth century. Their art devotes itself primarily to ancestor figures, probably formerly carved for the ritual of an ancestor cult, and fetish figures, ranging in size from the big konde *or nail-fetishes to small carvings worn on a necklet or attached to the waistband. To give the figure its fetish quality, "medicine"—a gummy substance—is applied to the head*

45

or abdomen or inserted in a cavity; into this substance a tooth or bits of glass are sometimes introduced. The customary ingredients of a witches' cauldron are drawn upon according to the use which the fetish is intended to serve.

★31-A. Wooden figure of a naturalistically carved standing woman with head turned to right and hands on hips. There are traces of tukula powder on this fine old piece. H. 26″. The Ethnographical Museum, Antwerp.

★31-B. Wooden figure. This maternity figure is a characteristic "fetish" carving of the Bakongo, representing a mother and child with magic substances applied to the small of the woman's back and to the child's abdomen, where it is covered by mirrored glass. It is sculptured of the light colored hard wood often used by the Bakongo and details of coiffure, filed front teeth, ear, body scarification and necklace are realistically presented. H. 10½″. The Brooklyn Museum, Brooklyn.
 Exh. Brooklyn, 1954. Ill. Brooklyn, No. 142.

31-C. Wooden figure in the form of a standing dog. There is a hole for the medicine or magic substance in the middle of the back. L. 11½″. Mr. and Mrs. E. Clark Stillman, New York.

★31-D. Large wooden figure studded with nails, knives, and other pieces of iron, called konde by the Bakongo. H. 42″. The University Museum.

31-E. Group of two pot lids of wood. These are two of the "proverb plaques" of the Bakongo, although we are ignorant of the meaning of the small flying bird with a stick in his beak, or the two birds kissing, surrounded by four small unidentified objects. They were collected in 1951 in Portuguese West Africa by Mr. Carlos Claro for the American Museum. Diams. 7½″ and 6½″. The American Museum of Natural History, New York.

31-F. Wooden bell or rattle, circular and hollowed out thinly, with geometric and concentric decoration over its surface and a dog or other mammal carved in the round on the top. There are three wooden tongues or clappers with conical heads. H. 6½″. Miss Susanne C. Klejman, New York.

32. BAYAKA

The Bayaka live along the Kwango River, a tributary of the Kasai which drops sharply to the south in the lower part of the Belgian Congo. Their art as well as their culture resembles closely that of the neighboring Basuku tribe, but is easily distinguishable by the characteristic Bayaka turned-up nose that gives a comic look to much of their carving.

★32-A. Wooden dance mask with dried grass ruff. This dance mask may be Basuku work and probably represents an evil spirit. L. 14″. Mr. and Mrs. James M. Osborn, New Haven.

32-B. Wooden mask with dried grass ruff. The mask is composite, the face being carved of wood with the upturned Bayaka nose and attached to a framework of reed covered with painted raffia cloth with an elaborate superstructure of an animal as a sort of mobile decoration. Young men wore masks such as these during the celebrations attendant on their circumcision and acceptance as men of the tribe following their year of study in the Bayaka "Bush University." H. 28". Mr. Julius Carlebach, New York.

33. BAPENDE

The Bapende live partly in the Kwilu River basin and partly on the Kasai and are chiefly known for their dances and celebrations connected with initiation rites. Masks and figures are treated heavily with tukula powder as a cosmetic (as are the bodies of the Bapende people). Tukula is made by grinding camwood to powder.

33-A. Group of small ivory, wood and bronze carvings. These small amulets representing human faces, with eyes closed, eyebrows meeting over the nose, and coiffure arranged, usually, in three tufts, are worn as pendants by Bapende men from the time of initiation into the tribe onwards. Ave. L. 2". Mr. John J. Klejman, New York, The British Museum, Webster Plass Collection, and the University Museum.

33-B. Standing female figure in wood with hands on the stomach, reddened brightly with tukula and touched with kaolin and black color. The face is typical of the Kasai Bapende. This piece was fully documented by Prof. Frederick Starr when he collected it in the field for the American Museum of Natural History in 1910. It is a pleasure to record that so many pieces in this exhibition, such as those collected by Starr and Lang for the A.M.N.H. and those collected in the field for the University Museum before 1920, and purchased by various directors before that date, are of such fine quality. They disprove that myth so firmly established in the folklore of modern art, that it was Picasso and his friends who discovered African Art. In William Fagg's words, "What the Post-Impressionist adventurers discovered was a method of *mis*understanding tribal art, by ignoring the whole motivation and philosophy of the tribal artist and making use only of the outer forms of his works as patterns to please or surprise the public." H. 22½". American Museum of Natural History, New York.

★33-C. Wooden mask, with red and black face and white decoration. The eyes are projecting cylinders and there are two long straight horns; note also the Bapende eyebrows meeting over nose. This also was collected by Prof. Frederick Starr in 1910, in the Eastern Bapende village of Golongo. There is a piece almost duplicating this mask on display in the Ethnographical Galleries of the British Museum from the Torday Collection. H. 24¼". The American Museum of Natural History, New York.

47

★33-D. Wooden mask, heavily treated with tukula powder, as 33-C, and surmounted by two human figures, male and female. Also collected by Prof. Starr at Golongo among the Eastern Bapende, this mask is outstanding in imaginative conception. H. 14½″. The American Museum of Natural History, New York.

33-E. Wooden mask in stylized human form, used in initiation rites. These masks, like the small pendant ivories, have the appearance of dead or sleeping faces possibly because the young men, after initiation, are supposed to be reborn to life as adult members of the Bapende tribe. The style is that of the western or Kwilu Bapende. H. 16″. The University Museum.

33-F. Wooden mask of the same style as 33-E, also used in initiation rites. H. 12″. The Allen Memorial Art Museum, Oberlin.
Exh. Oberlin, 1956. *Ill. BAMAM,* No. 71.

34. BUSHONGO

Of all the Belgian Congo tribes the most famous for their art production are the Bushongo or Bakuba. They are a very large tribe mostly living in the Kasai district and are divided into many sub-tribes: the Bambala, Bashilele, Bangongo, and others. Most of them are ruled by the Nyimi who has his court at Mushenge and who according to the oral history of his people is the 124th of his line. In this exhibition we cannot show any of their kings' portraits, which date from the sixteenth century onwards (by the evidence of their generally reliable oral history) and are among the oldest African wood carvings. Two of the early royal portraits are in the Musée du Congo Belge, three are in the British Museum and only one is still in private hands. Most of their work is decorative and their production of carved cups, bowls and boxes has been prodigious. Here, as among the Yoruba, there is a continuing tradition of art style and, with a little practice, the work of certain individual sculptors can easily be recognized. Pieces made for their own use are to be distinguished from the much greater number now made for the European curio trade—some of them too perfunctory, others overelaborate.

34-A. Wooden cup for the ritual drinking of palm wine, carved in the form of a human head with the curled horns of a ram. William Fagg, who has visited the Bushongo, believes this cup to be from the Pianga sub-tribe. H. 8″. The British Museum, Webster Plass Collection.

34-B. Wooden cup for the ritual drinking of palm wine, on a flaring neck carved with serrated bands and decorated in front with a large nodule. H. 7½″. The Yale University Art Gallery, Linton Collection.
Exh. Oberlin, 1956. *Ill.* Fagg, 1953b, pl. 40; *BAMAM,* No. 79.

34-C. Wooden box for tukula powder (powdered camwood) in the shape of a human face. This beautiful box is richly patinated with tukula mixed with palm oil. There is a hook for suspension fastened to the string-tied lid, so that the box can be hung out of reach of the white ants. It is probably from the Bambala sub-tribe. L. 8½″. The British Museum, Webster Plass Collection.

Exh. Cambridge, 1948; Oberlin, 1956. *Ill.* Fagg, 1953b, pl. 40; *BAMAM,* No. 80.

★34-D. Wooden box in the shape of a basket, completely covered with traditional incised decoration. This fine box was collected at Mushenge by Mr. Elisofon, and is exceptional for its size and apparent age. The main design encircling the box is called *ikuni na Woto,* the belly of Woto (a primeval ancestor of the tribe). H. 9½″. Mr. Eliot Elisofon, New York.

★34-E. Tukula powder box of a style similar to that of 34-D, also collected at Mushenge and similarly patinated by use. This piece is rare among large Bushongo boxes in that only one design (the belly of Woto, as in 34-D) is used on the lid and the body of the box. L. 12½″. Mr. Eliot Elisofon, New York.

34-F. Small turtle modeled from oil, gum and powdered camwood. Such objects were formerly given to the chief mourners at funerals by the heir of the dead person. This turtle was collected by Dr. Hans Himmelheber in the field in 1937 and was formerly in the Webster Plass Collection. L. 4″. Mr. William Fagg, London.

34-G. Wooden mask of naturalistic proportion, decorated with beadwork along the median line of the nose and mouth and along the eyebrows, and with painted geometric decoration all over the face; the top is ornamented with cowrie shells. This type of mask is often attributed to the Bena Lulua and appears in fact to be common to them and to the Bushongo; but it is clear from the form of the nose and mouth and the style of the painted decoration that use of these masks by the Bena Lulua is due to borrowing from the Bushongo. H. 10½″. Mr. M. L. J. Lemaire, Amsterdam.

35. BENA LULUA

The Bena Lulua are chiefly known for their wooden figure carvings, the best of them very old and outstanding for their delicacy and grace and for their combination of sculptural and decorative excellence. They are a small tribe who live to the south of the Bushongo.

35-A. Wooden figure. Leo Frobenius, the great German Africanist, collected this aristocratic little figure in the field in 1905 and it was given by him to the Hamburg Museum (the museum's number is visible on the right leg). It is probably male and gracefully slender, standing with a short staff in the right hand and a small bowl (showing traces of lime or kaolin) in the left. The coiffure rises to a slender double point at the top and to two cylindrical projections at the back of the neck. The face and body are elaborately cicatrized in high relief

and the whole piece has been richly patinated with tukula and palm oil. Formerly in the private collection of M. Charles Ratton, Paris, this piece has been widely exhibited both in Europe and America. H. 16½". The British Museum, Webster Plass Collection.

> *Exh.* Cambridge, 1948; Brooklyn, 1954; Oberlin, 1956. *Ill.* Fagg, 1953b, pl. 42; Oberlin, pl. 75.

★**35-B. Female figure holding child,** on a tapering cylindrical staff, delicately and gracefully carved. This may well be considered the finest Bena Lulua sculpture in America. H. 14". The Brooklyn Museum, Brooklyn.

> *Exh.* Brooklyn, 1954. *Ill.* Brooklyn, cover and No. 196.

35-C. Pipe with elaborately carved bowl in the form of a human head resting on an outstretched human left hand, an outstandingly imaginative conception. L. 19". The Ethnographical Museum, Antwerp.

35-D. Small wooden tobacco mortar. The squatting human figure in knee-chin position forms the container and the lid is attached by string to the back of its neck. It is heavily patinated and is a rich dark brown in color. The relation of the feet to the base is sculpturally interesting. H. 3½". The Ethnographical Museum, Antwerp.

35-E. Fragment, head only, apparently from a figure like 35-A. This lovely head was collected in the Congo by the lender. H. 4½". Mr. Eliot Elisofon, New York.

36. BALUBA

The Baluba form an important ethnic group in the southeast of the Belgian Congo, between the Bushongo and Bena Lulua area and the shores of Lake Tanganyika. The Baluba are a tribal complex, once united, in the Middle Ages, in the powerful Lunda Kingdom, who share certain inherited common traditions, but also express individual tribal tendencies and beliefs, evident in differences of style. Baluba art found its best expression in simple but most subtly and artistically executed female figures, usually with the tribal scarifications carved in high relief. Some of their best carvings are considered as among the finest masterpieces of African sculpture.

36-A. Standing male ancestor figure in wood. The head and torso are carved in perfect balance. There is a splendid rhythmic line continuing from the great feet, up through the legs and into the arms leading to the expressive and sensitive head. The figure is carved of dark hard wood, patinated to a high polish. H. 35½". The Ethnographical Museum, Antwerp.

> *Ill.* Olbrechts, pl. 138 and 150.

36-B. Wooden bowl held by seated figure. This sculpture is of blackened hard wood, highly patinated, with the tribal markings carved in high relief. L. 25". M. Charles Ratton, Paris.

> *Ill.* Tempels, p. 52.

★36-C. Small wooden headrest consisting of two seated figures holding each other with outstretched arms that form an intricate but perfectly balanced design with the legs. The figures both wear "cascade" coiffures. H. 7¼". M. Charles Ratton, Paris.

Ill. Tempels, p. 28.

36-D. Wooden figure of a woman seated on an openwork stool with her feet turned towards the front. She appears to be wearing a conical cap on the back of her head and she is holding her breasts in her hands. While not one of the great achievements of African art, this piece none the less has a winning charm. It is of extremely light wood and is stained black. H. 9". The British Museum, Webster Plass Collection.

Exh. Antwerp, 1937. *Ill.* Olbrechts, pl. 101.

36-E. Wooden figure of a male standing on an animal. The treatment of the head and the general feeling of this representation make it clear that this figure was carved by the same sculptor as 36-D. H. 9½". Mr. and Mrs. E. Clark Stillman, New York.

Exh. Antwerp, 1937. *Ill.* Olbrechts, pl. 103.

36-F. Wooden figure of a woman, kneeling, holding above her a bowl with wide cross-hatched border. This beautiful piece of sculpture is notable for the careful treatment of the swelling thighs, often so weakly portrayed by the Baluba. The intricate design of the scarification on body and arms is carefully executed and the woman is adorned with strings of beads at hips and neck. H. 23½". M. Charles Ratton, Paris.

Exh. Brussels, 1930.

36-G. Wooden figure of a seated woman holding bowl, with typical Baluba coiffure arranged over a cane foundation. Such pieces were formerly called "mendicant" figures, but they probably served a more general purpose in the tribal culture. This beautiful work is carved from hard brown wood, highly patinated. H. 12½". The University Museum.

Ill. Wieschhoff, fig. 5; Wingert, pl. 101.

36-H. Wooden stool supported by a squatting female figure, with macaronic legs and feet turned outwards. The round base of the sculpture has carved ornamentation corresponding to that of the seat. The caryatid figure itself, in its well-planned angularity, and the complicated scarifications carved carefully in high relief, point to the use of this stool as a throne reserved for the tribal chief. H. 16½". The University Museum.

Ill. Wieschhoff, fig. 4; Wingert, pl. 102.

★36-I. Wooden dance mask of hemispherical form, intended for wear horizontally, like an umbrella hat. It is colored black and the deeply incised cuts are filled in with kaolin or a similar white substance. This is the Baluba type of *Kifwebe* mask, as distinct from the Basonge type (37-D). H. 22". The University Museum.

51

37. BASONGE

The Basonge, northwestern neighbors of the Baluba, living chiefly in the Belgian Congo province of Lusambo, are strongly influenced by the Baluba, but have also found individual expression in their figures and masks, which are angular and cubistic in treatment as opposed to the fluid line of Baluba art. It would seem that their figures are generally fetishes rather than ancestor figures as among the Baluba. The Basonge (again unlike the Baluba) often adorned their figures with copper strips and imported brass-headed nails, sometimes cone-shaped, and girt them with leather and snakeskin belts, and necklets containing "magic" substances. Their kifwebe *dance masks are highly stylized not only in form but also in the all-over pattern of parallel incised lines covering the faces, rubbed over with kaolin to give a black and white striped effect.*

37-A. Male fetish figure carved in wood with large head, widely spaced heavily lidded eyes, and rectangular mouth. The long neck is carved with three concentric rings. Stripes of patinated copper on the face increase its aggressive expression. Unusual for this tribe are the flexed legs almost in a kneeling position, perhaps with some special symbolism. The "magic" of this figure is contained in small linen bags, one inserted in the navel and one in a cranial cavity; they are fastened with small wooden pegs. Other thaumaturgical appurtenances are the container of snakeskin which is slung about the body on a leather strap and the leopard's tooth which hangs from the neck on a twisted leather band. The cranium is covered with a strip of leopard skin (the spots are still visible) and a hand-forged iron ring protrudes from the head as an added symbol of strength and power. This figure is said to be a "leopard fetish" and it is said that a witch-doctor, when called upon to avenge an offense to one of his tribesmen, could, through the power of this fetish, command an actual leopard to kill the offender. That this figure was held in high esteem by its Musonge owner is indicated by the use of home-made metal clamps to hold together the cracks appearing through the head and body. The carving was collected by Dr. Hans Himmelheber on his 1931 expedition to the Congo. H. 14″. Mr. Eric Peters, New York.

37-B. Wooden fetish figure of a small standing man, of a more gentle type than 37-A and presumably used for healing by the medicine man. The "medicine" is inserted in head and navel and the power is enhanced by the use of copper and nails on head and belly. Collected by Dr. Himmelheber on his 1931 expedition. H. 8″. Mr. Eric Peters, New York.

37-C. Male fetish figure of "classical" type with the great feet firmly gripping the hemispherical pedestal. The mouth, like a horizontal figure eight, the heavy-lidded eyes and the stylization of the big head give it an intense and powerful expression. It is regrettable that the former owner gave it a good scrub and removed all the magic but noxious substances that once filled the

deep holes in head, torso and legs, and for this she does penance ten years later as compiler of this catalogue. H. 16½". The British Museum, Webster Plass Collection.

37-D. Wooden dance mask (*kifwebe*) with a flowing sculptural line from rounded forehead to jutting chin. The large heavily lidded eyes dominate the face and their lines are echoed in the incised and limed parallel hatching which covers the mask against a dark-stained background. Dr. Olbrechts considers such masks to show Baluba influence. They are said to be of the type worn by witch-doctors. H. 14½". The British Museum, Webster Plass Collection.
Exh. Oberlin, 1956. *Ill.* Fagg, 1953b, pl. 45; Schmalenbach, pl. 110; *BAMAM*, No. 72.

★37-E. Wooden stool for a chief, in light wood with light brown patination. A bearded man supports the circular seat on his head and upraised arms. The large feet and thick lower legs convey an idea of great stability to this figure as does the massive head with black-stained coiffure and the thick neck with triple rings encircling it. H. 20". The British Museum, Webster Plass Collection.
Exh. New York World's Fair, 1938.

38. BAJOKWE

The Bajokwe, often referred to as Badjok, Chokwe, Vatchivokoé, Kioko, etc., were part of the great medieval Lunda kingdom of the Western Congo and Angola, along with the Baluba and Basonge. They are a wide-spreading tribe found all the way from middle Angola to Lake Tanganyika, and their influence is shown in the work of many of their neighboring tribes, from whom they often themselves absorbed cultural and stylistic traits. But even when imitating the forms of, say, Baluba stools, they always retained their own distinctive style, which cannot be mistaken for a sub-style of any other.

38-A. Top of wooden staff in the form of a human head with coiffure of elaborate Bajokwe style. The head surmounts a flattened staff top carved in a form which seems to owe something to Portuguese baroque influence, though its incised decoration is probably indigenous. H. 16¼". M. Charles Ratton, Paris.
Ill. Schmalenbach, pl. 143.

★38-B. Dance mask. Such sensitive and beautiful masks from the Bajokwe are rare indeed and this is complete with its crocheted head-covering and other accoutrements. It shows such characteristic features as the "spectacled" eyes, large mouth and tribal scarifications, and is of the type called *mwana pwo*, the maiden. H. 14". Mr. M. L. J. Lemaire, Amsterdam.

38-C. Wooden standing male figure with head like 38-A and powerfully sculptured body. Its big hands (one of which is restored) and feet are carved

in accurate detail. It is an excellent piece of Bajokwe sculpture, acquired by the Commercial Museum of Philadelphia early in this century. H. 16″. Commercial Museum, Philadelphia.

Exh. Brooklyn, 1954. *Ill.* Brooklyn, No. 188.

38-D. Chair of wood, carved at top and on the rungs with small figures. This little chair (typical of Bajokwe variations on the form of old European chairs) was exhibited at the Theatre Arts Exhibition in New York in 1927. H. 25″. Mr. and Mrs. E. Clark Stillman, New York.

39. MANGBETU

One of the important tribes of the northeastern part of the Belgian Congo are the Mangbetu, who live on the fringes of the great Ituri forest, near the Anglo-Egyptian Sudan. They are well-known for their habit of binding babies' heads to elongate them in a graceful fashion. Most of their art was expended on various artifacts, pots, musical instruments, bark boxes, and small ivory amulets, and they have become great practitioners of the curio trade.

★39-A. Wooden harp, topped with a well carved head of a Mangbetu woman. The instrument is in an excellent condition, considering that it was collected in the field for the American Museum of Natural History, New York, as long ago as 1915 by Dr. Herbert Lang. Drs. Lang and Chapin went to Africa for six years in 1909 on an ornithological field trip for the American Museum. The great ethnographical collections from the Belgian Congo made by them at that time were purely a by-product, but are a superb example of their discrimination and taste in collecting. H. 21″. The American Museum of Natural History, New York.

39-B. Bark box topped with carved wooden head. Not very many of the pieces from the Mangbetu have great aesthetic merit, but the carver of this elongated head with the Egyptian look to it was a sculptor of some feeling and better-than-average talent. The bark cylindrical boxes were used for secular purposes, it is believed. H. 11″. Mr. and Mrs. E. Clark Stillman, New York.

Exh. Oberlin, 1956. *Ill. BAMAM,* No. 82.

40. WAREGA

Dr. D. Biebuyck of Bukavu, in the Belgian Congo, has lately written three studies of this little-known tribe. He himself has been initiated into the tribe and is now a member in full standing; he has collected for the Musée Royal du Congo Belge at Tervuren a superb group of wood and

54

ivory sculptures and of ethnographical material from the Warega (or, as he calls them, Balega) which is unsurpassed in the museums of the world.

The Warega live in the province of Costermansville, Belgian Congo, a country once rich in elephants; it is no doubt for this reason that much of their sculpture is executed in ivory. Their masks, like their ivory fetishes and amulets, are small, but the best of them and the best of their wooden sculptures are unexcelled in simplification of form and sensitivity of feeling. Their art is chiefly consecrated to the service of their powerful secret society, the Mwami. Dr. Carl Kjersmeier writes: "Their capricious dance staffs, ornamented with sculptured white painted masks, audaciously grouped, are in their effect most captivating," and he also speaks of the "profound and pure gravity" of their wooden masks.

40-A. Group of work from the Warega, kindly lent to us by Dr. Biebuyck from his private collection in the Congo, but unfortunately arriving too late for description in the catalogue.

★40-B. Standing female figure carved in wood and heavily treated with kaolin. The hands are joined at the top of the head. The Belgian Government presented this wood carving along with 40-C and 40-D to the American Museum of Natural History in 1907. The face of this piece has a certain similarity of form, especially in the slanted eyes set in a shallow concavity, with the faces of certain masks of the Bakwele tribe in the French Congo (see example 24-A to D, in which, however, the eyes are not slanted). H. 8¼″. The American Museum of Natural History, New York.

★40-C. Wooden mask of hard light brown wood, treated with kaolin (powdered white clay). Here is an example of that "profound and pure gravity" of which Dr. Kjersmeier writes. Its extreme simplification of form makes it a most moving work of art. It was a gift of the Belgian Government to the American Museum of Natural History in 1907. H. 8¼″. The American Museum of Natural History, New York.

★40-D. Small wooden hand mask with handhold on reverse of face. There is a ritual dance among the Warega in which the dancers wear a mask such as 40-C and carry a mask like this in each hand. Small ivory figures are often found wearing three masks, one on the face and one attached to each shoulder. The face in this little mask is somewhat like that of 40-C. It was also presented in 1907 by the Belgian Government to the American Museum of Natural History, New York. H. 5½″. The American Museum of Natural History, New York.

41. BAMBOLE

The Bambole are a little-studied tribe who live on the Lomami south of Stanleyville, in the north central part of the Belgian Congo. Such tall thin

figures as the two we show here are occasionally found in a few museums in Europe and no other art form has been reported from this tribe. The faces of these figures bear a remarkably close resemblance to the white-faced masks of the Fang of the Gaboon, 1,000 miles due west of the Bambole; as few of the figures are well documented, this has led to some incorrect attributions. But a connection may well exist between the two styles, since the Fang are believed to have migrated from the Upper Congo region to the coast within the past three centuries. Dr. Maesen of the Musée Royal du Congo Belge has recently made a short study of this tribe.

★41-A. **Wooden figure.** This long thin female figure with forward thrusting shoulders and hands on hips has a curved, relaxed back. The small dished-in face is painted with a yellowish pigment and there is other color apparent. Like all Bambole figures it is carved from a soft wood with a pithy core; a tubular hole is usually found (as here) to pass through the head and trunk where the pith has dried out. This piece was presented to the American Museum of Natural History by the Belgian Government in 1907. H. 30″. The American Museum of Natural History, New York.

★41-B. **Wooden figure.** Though this male figure is clearly of the same style as the last, the carver has treated his subject in a rather different and more formal way, with more emphasis on smooth planes. H. 30″. The University Museum.

Exh. San Francisco, 1948. *Ill.* Wingert, pl. 67, 68.

42. BAROTSE

In the upper reaches of the Zambesi River live the Barotse, in the western part of Northern Rhodesia. They trade to some extent with the Lunda-Bajokwe tribes, borrowing mask forms from them and even dances, but their own artistic production is in practice limited to dishes and covered bowls and seems to have no religious or magical purpose.

42-A. **Wooden dish with lid,** a pleasing elliptical covered bowl of hard wood, stained black. The lid fits exactly and the object seems to be designed in accordance with the best modern practice. There are two aquatic birds, possibly pelicans, swimming in line, represented on the cover in a beautiful and simple style. L. 17″. The British Museum, Webster Plass Collection. Museum, Webster Plass Collection.

Exh. London, 1951; Brooklyn, 1954; Oberlin, 1956. *Ill.* Imp. Inst., 1951, pl. 35; Fagg, 1953c, pl. 46; *BAMAM,* No. 84.

Photographic Credits

J. J. Breit, New York City 19-B

Walter Dräyer, Zürich 11-A

Eliot Elisophon 27-A

Lens-Art Associates, New York 1-H 8-B 11-L

Arthur E. Princehorn 2-B 18-D

Charles Uht 17-D

Charles Whitenack 16-E

Yale University News Bureau 32-A

Reuben Goldberg 1-E,F 2-G 5-A,C 7-C 8-E 10-F,I 11-B
 12-A 14-B,C 15-A,B,I,J,L,M,Q 16-A,I 17-A 18-A,D,E
 20-B 24-C,D 25-A,B 26-A,C 28-D,I 31-A,B,D
 33-C,D 34-D 35-B 36-I 37-E 39-A 40-B,C,D
 41-A,B

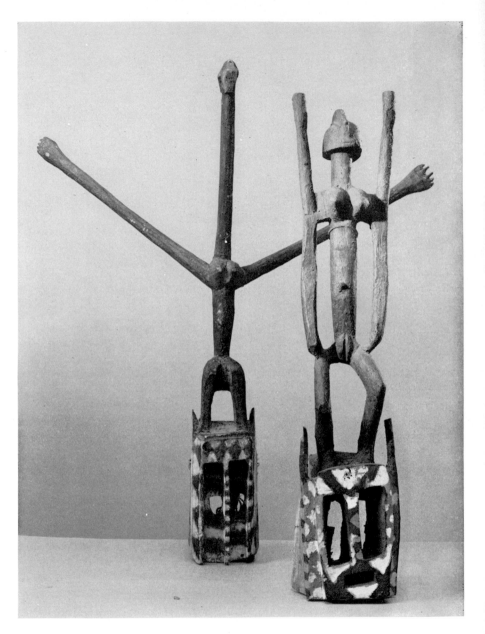

1-E 1-F

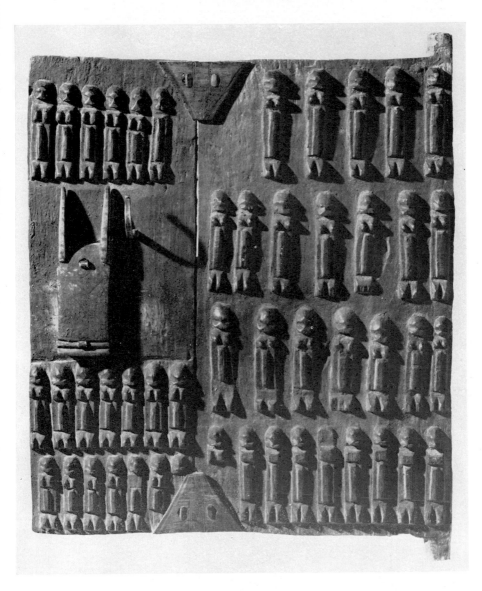

1-H

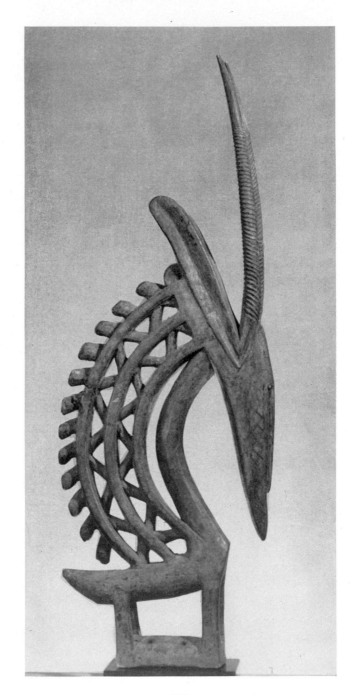

2-B

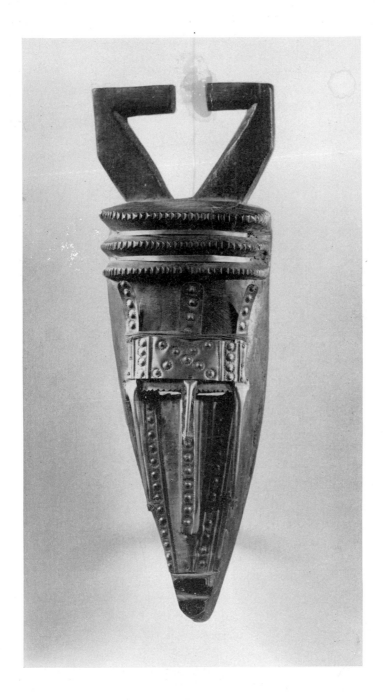

2-G

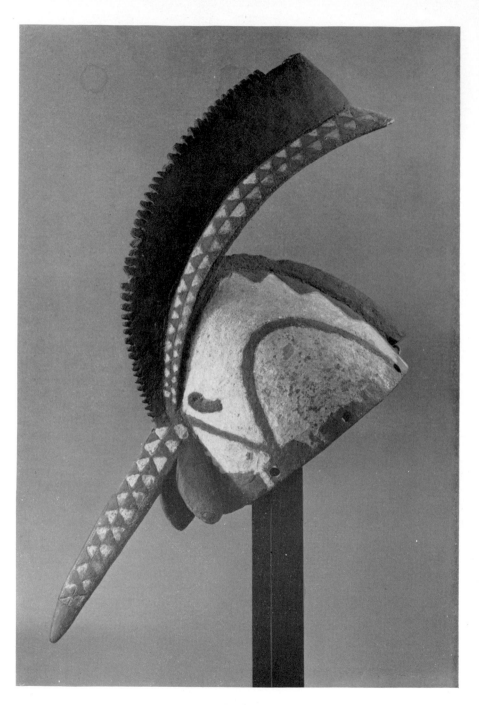

3-C

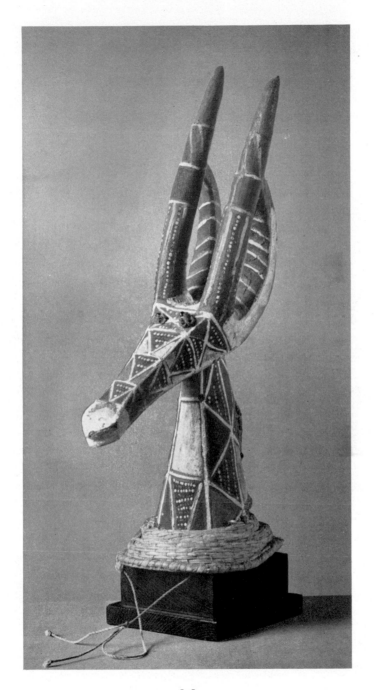

4-A

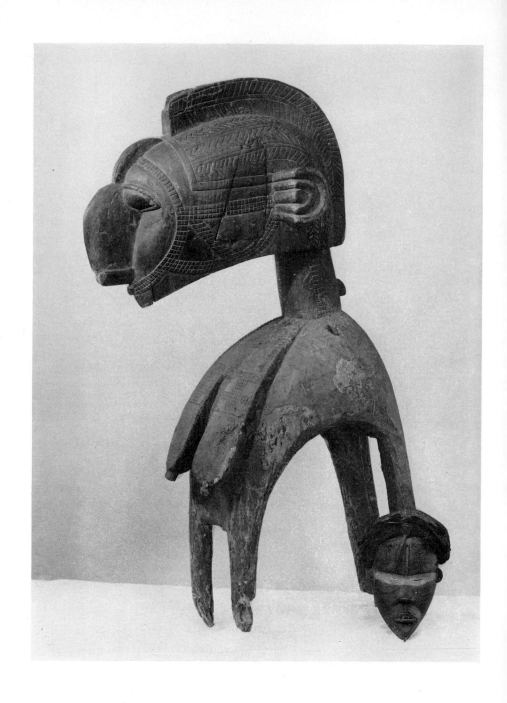

5-A 7-C

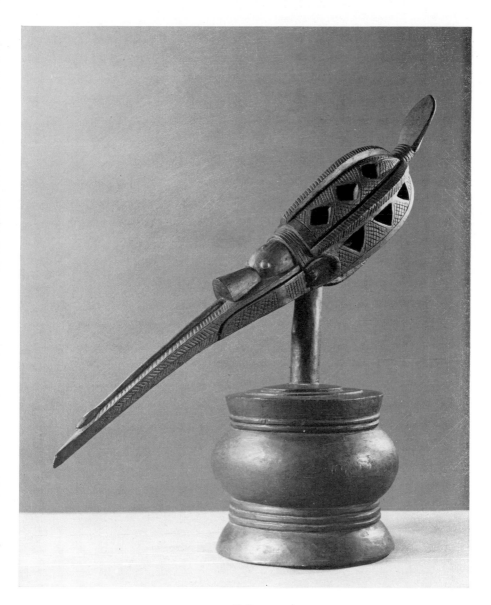

5-C

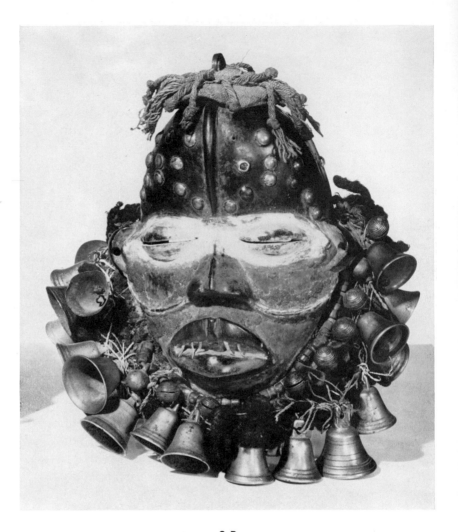

8-B

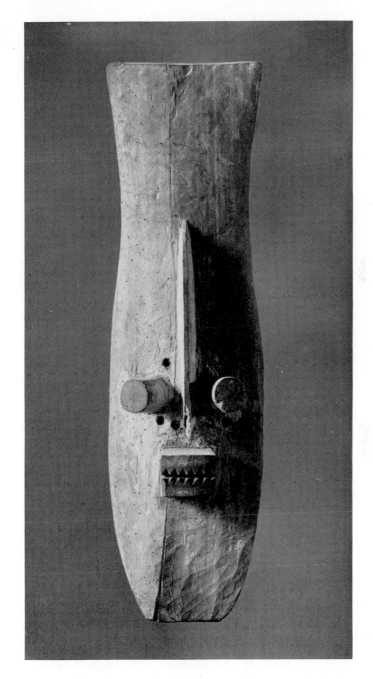

8-E

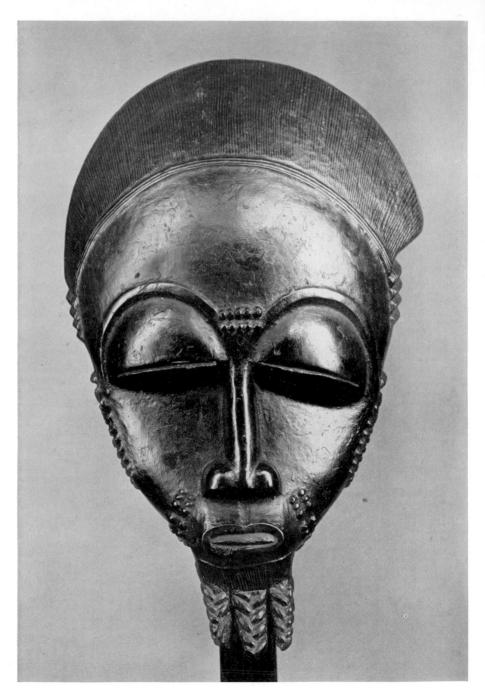

10-F

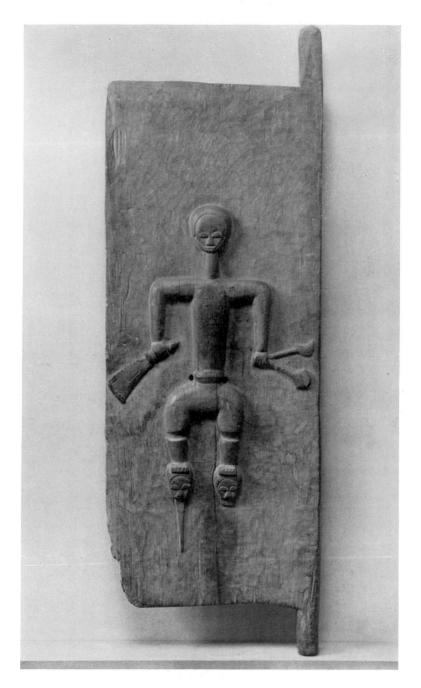

10-I

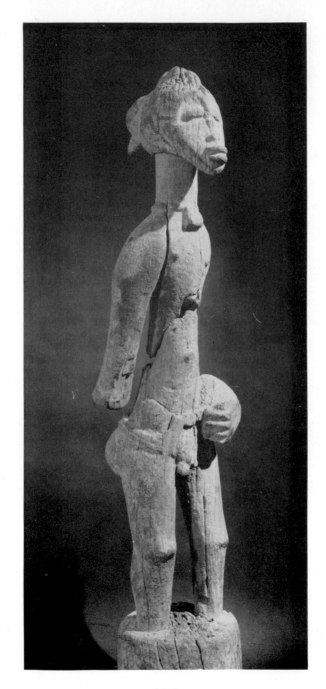

11-A

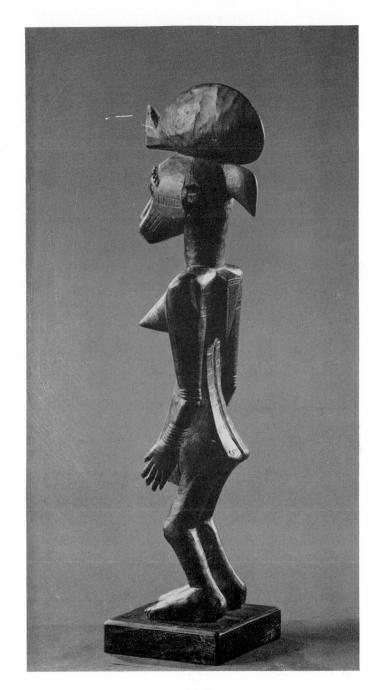

11-B

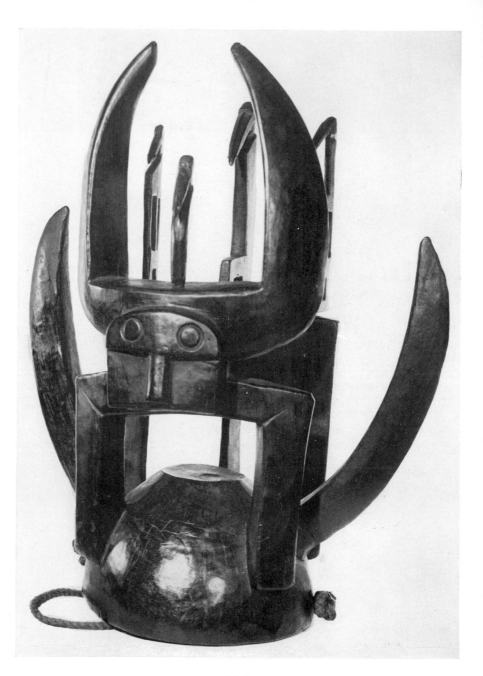

11-L

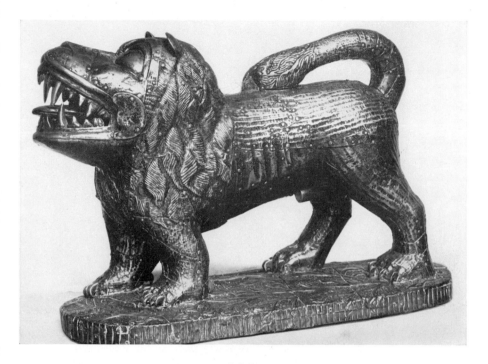

14-A

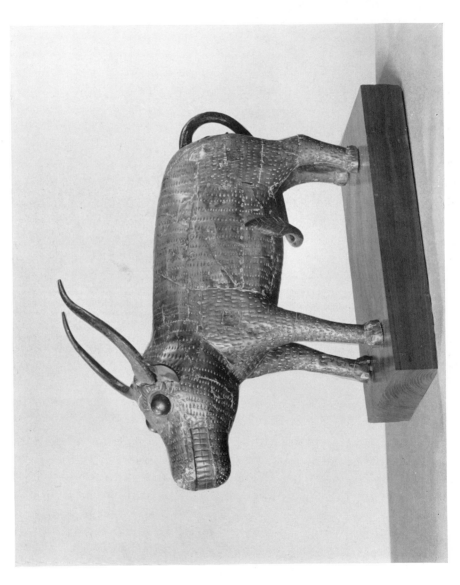

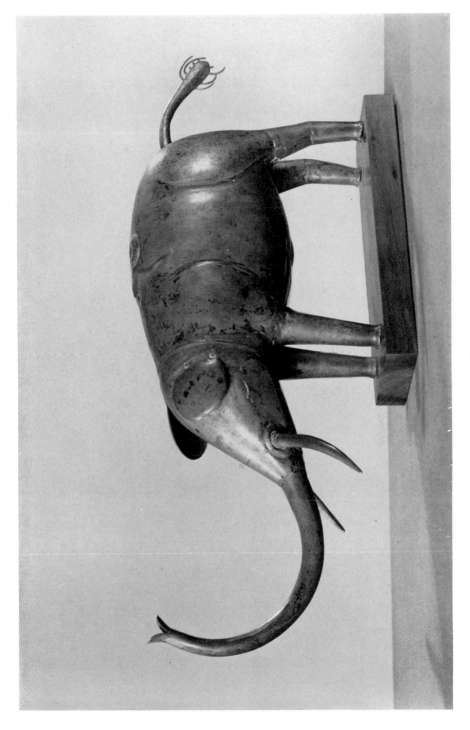

14-C

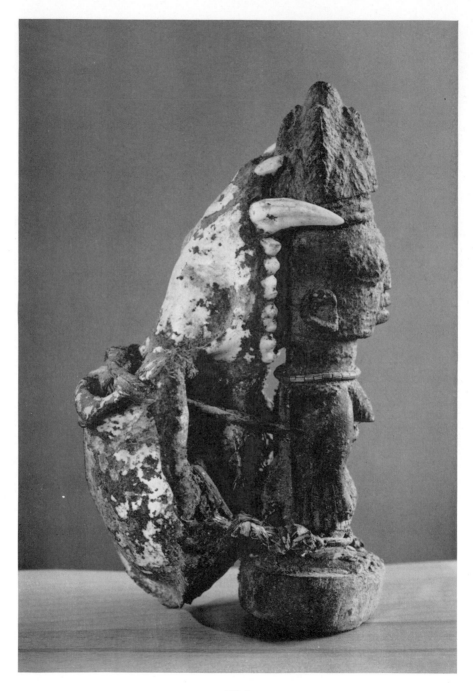

15-A

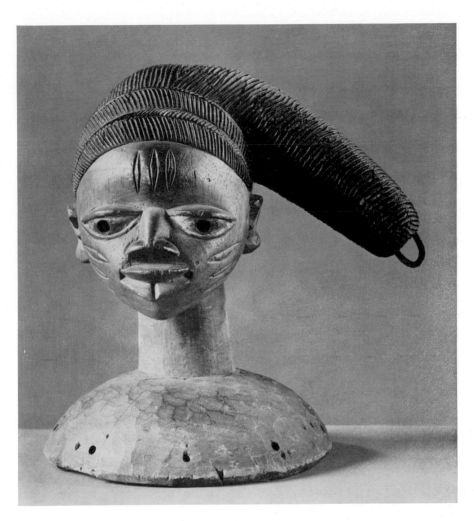

15-B

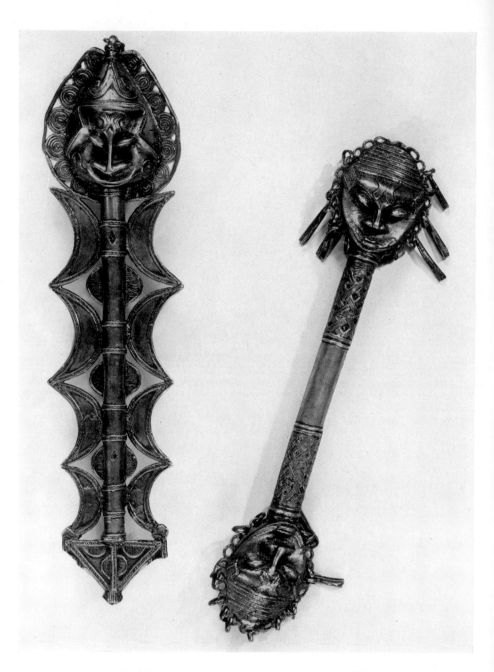

15-J 15-I

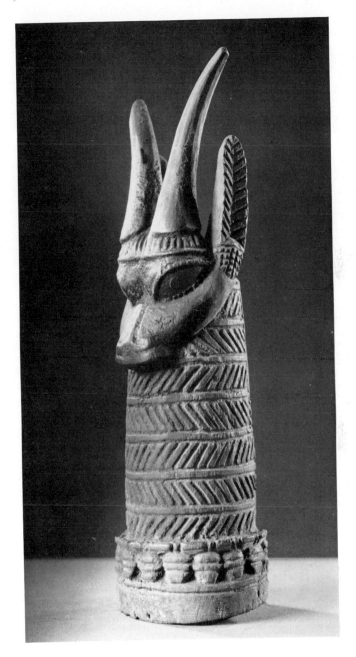

15-L

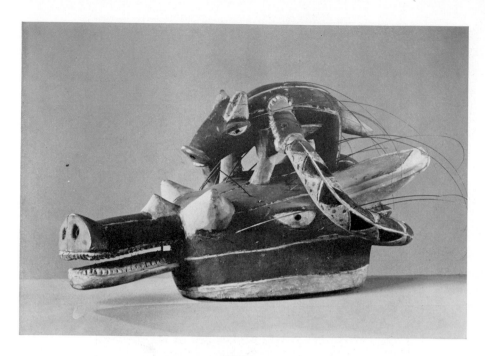

15-M

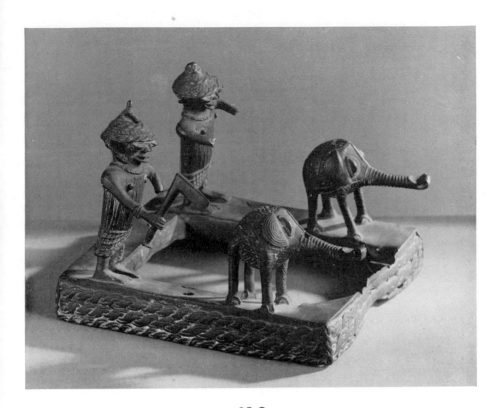

15-Q

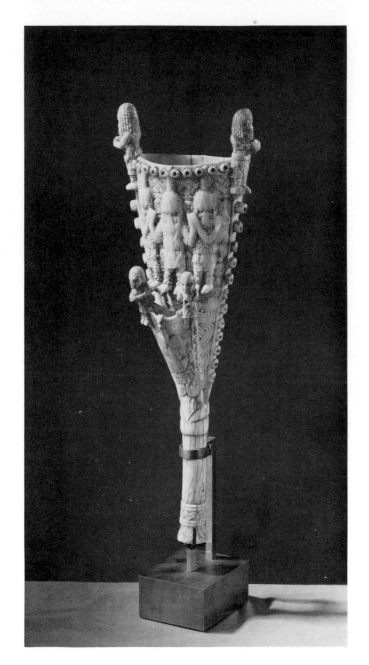

16-A

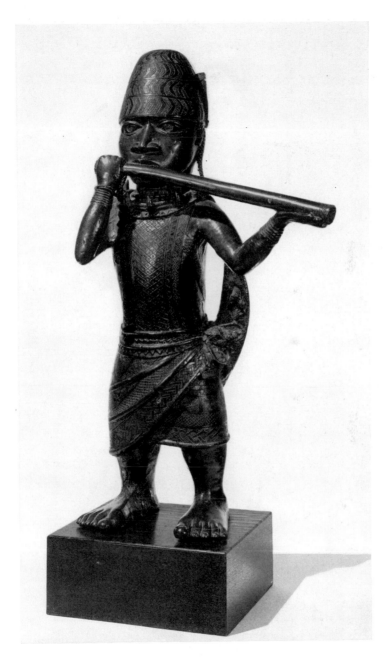

16-E

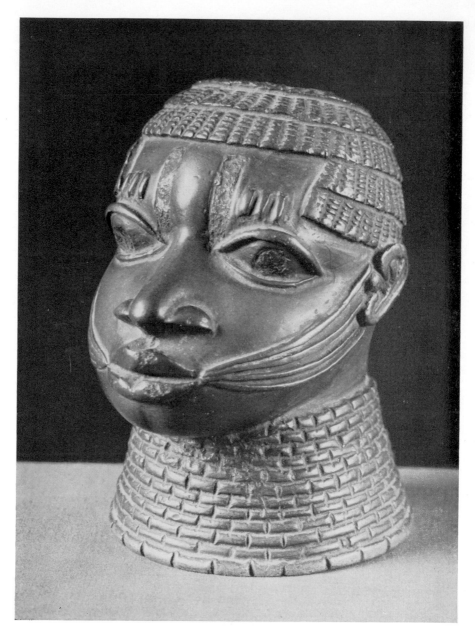

16-1

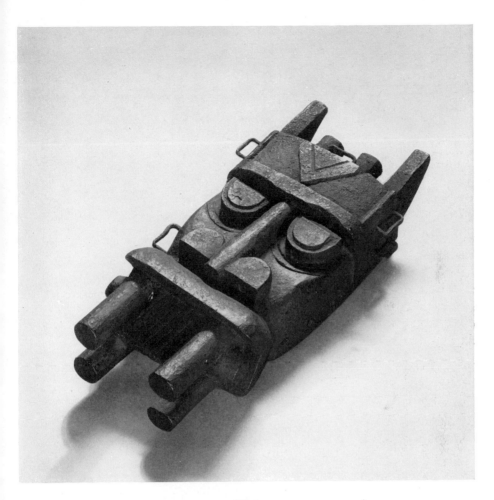

17-A

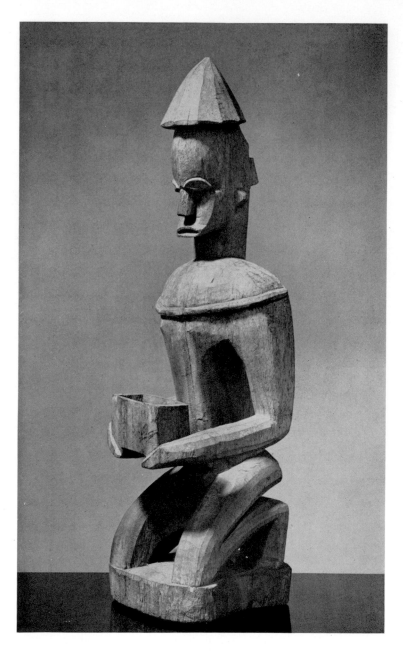

17-D

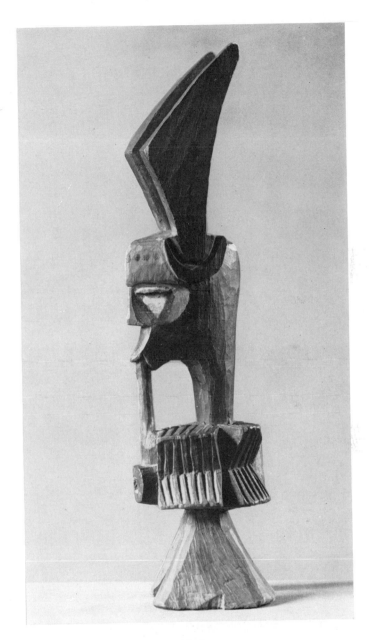

18-A

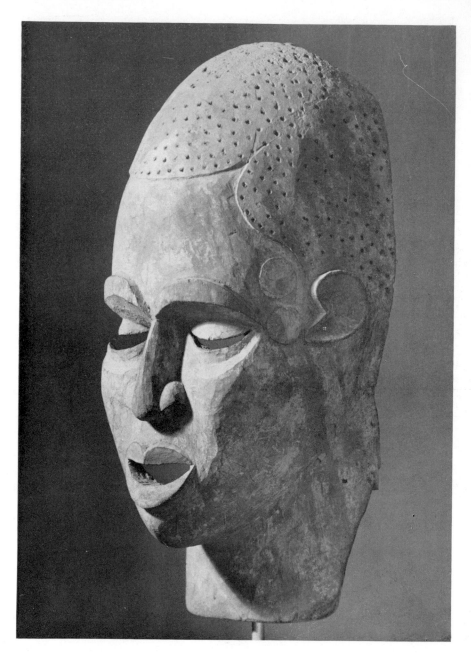

18-D

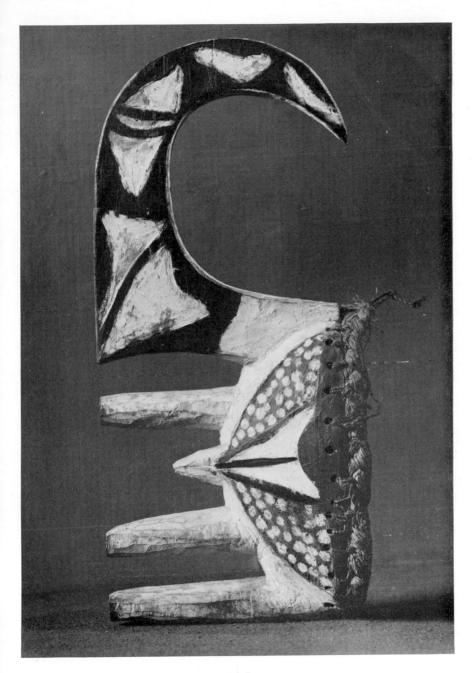

18-E

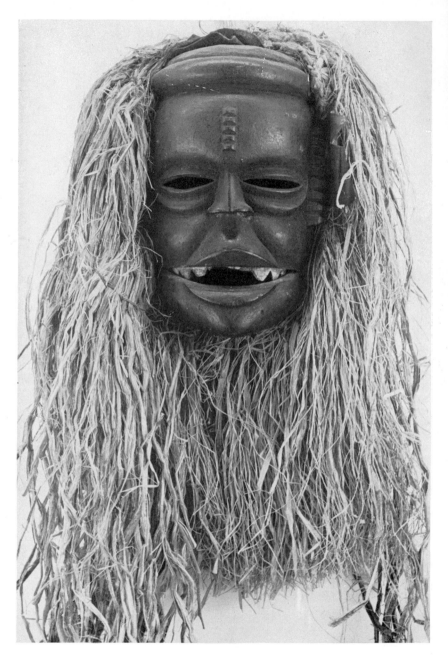

19-B

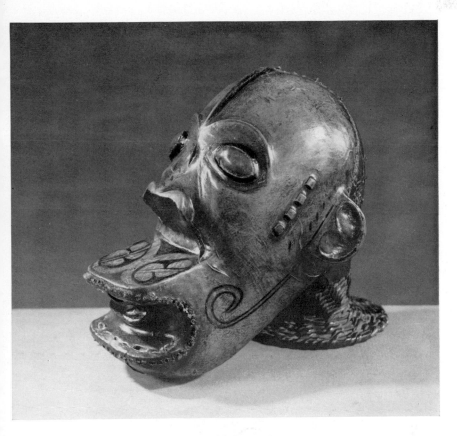

20-B

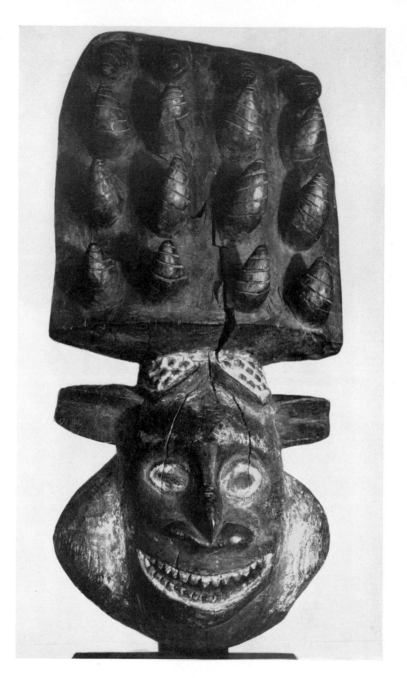

22-A

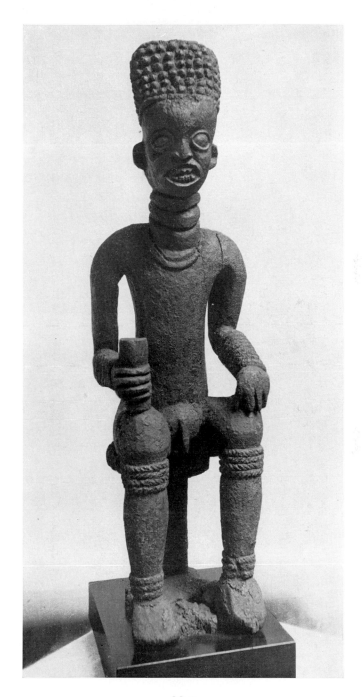

22-B

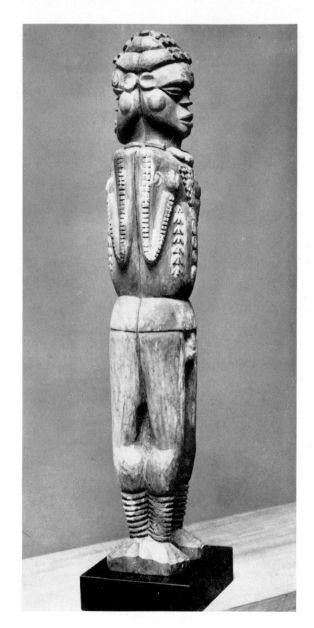

23-A

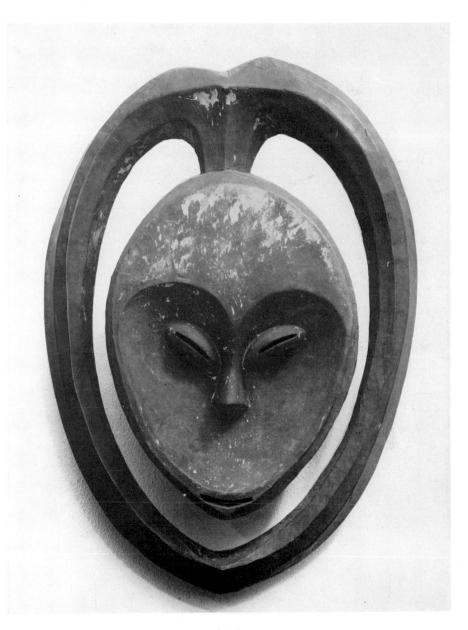

24-A

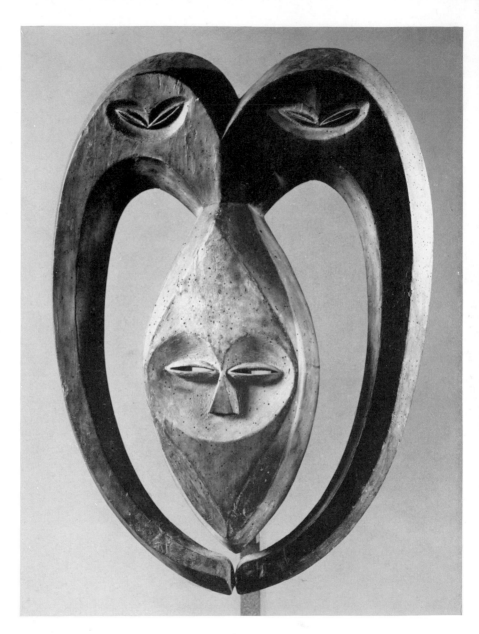

24-C

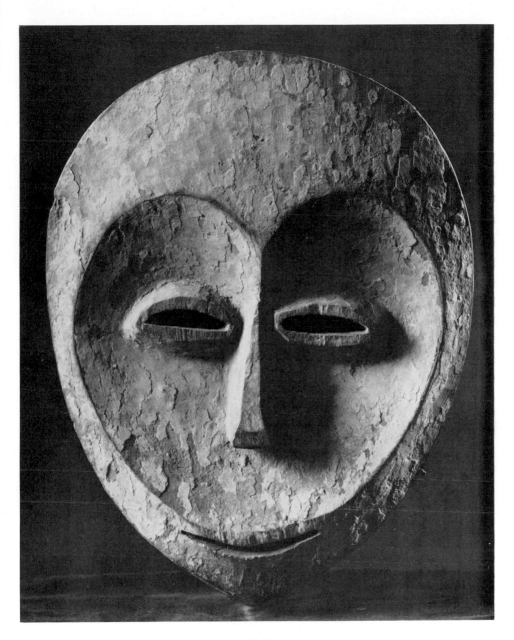

24-D

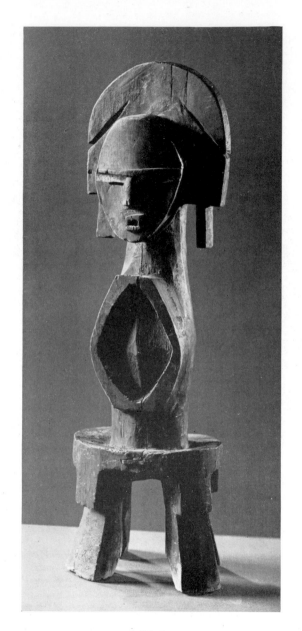

26-A

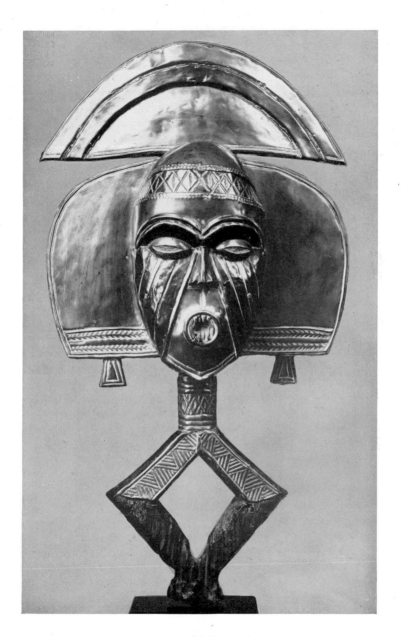

26-C

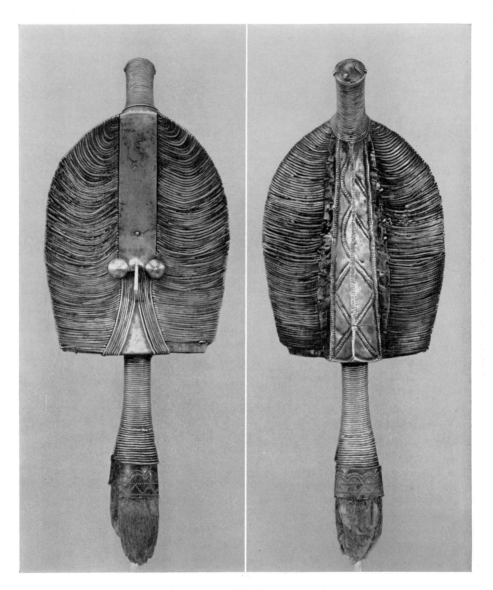

26-E

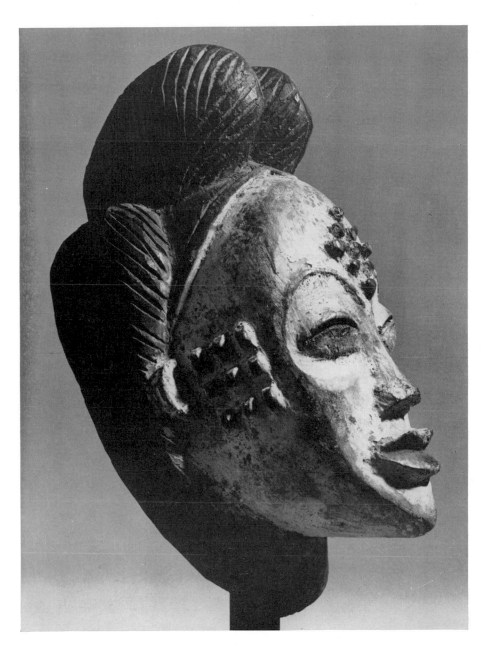

27-A

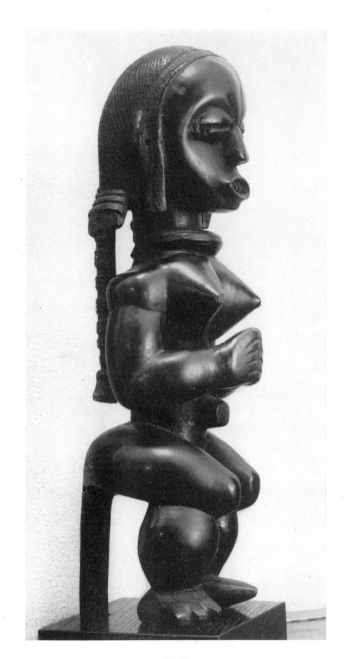

28-C

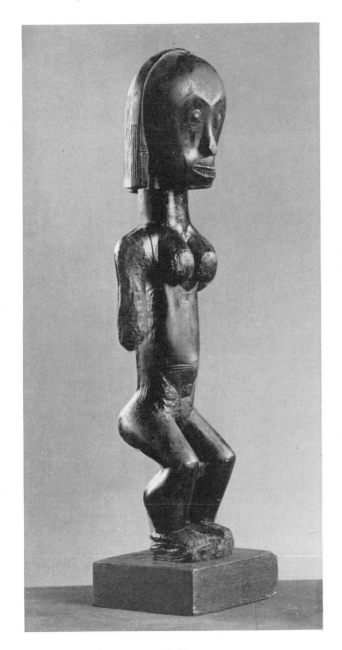

28-D

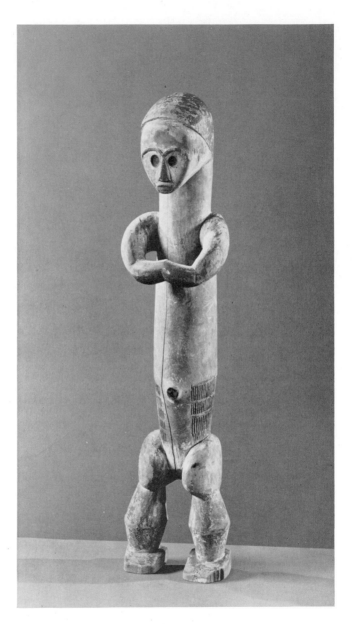

28-I

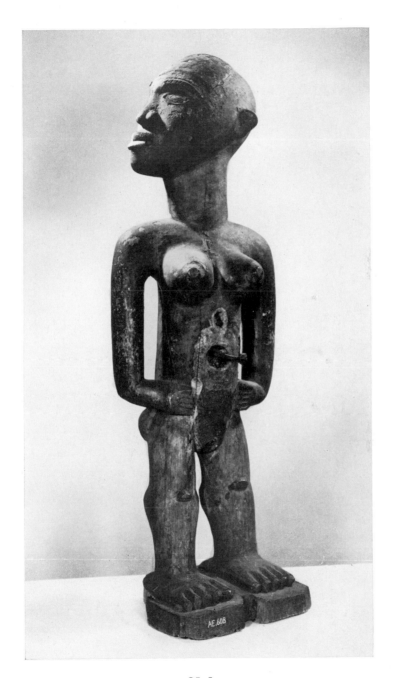

31-A

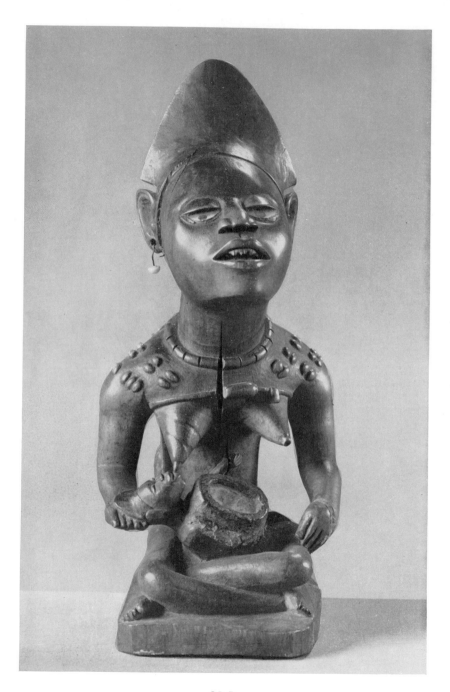

31-B

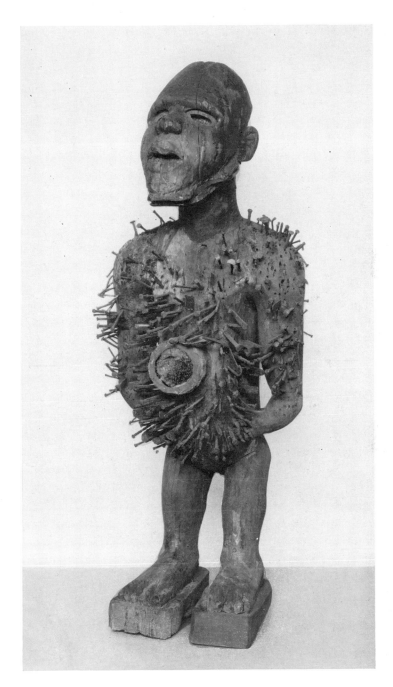

31-D

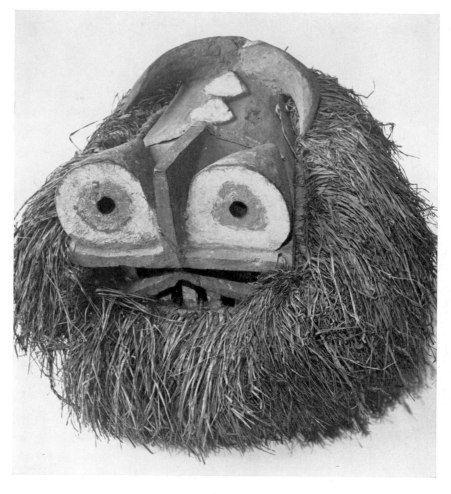

32-A

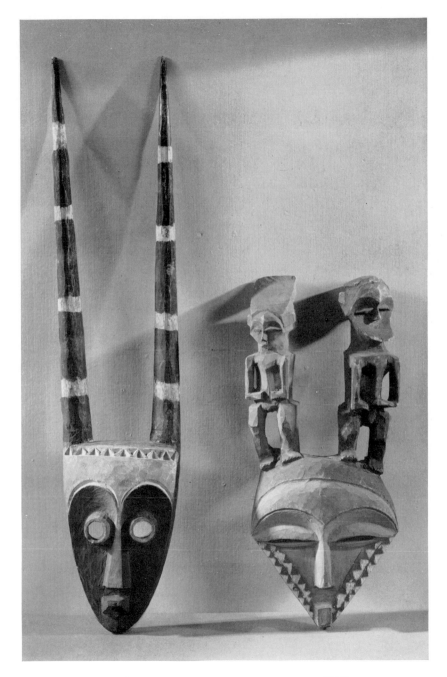

33-C 33-D

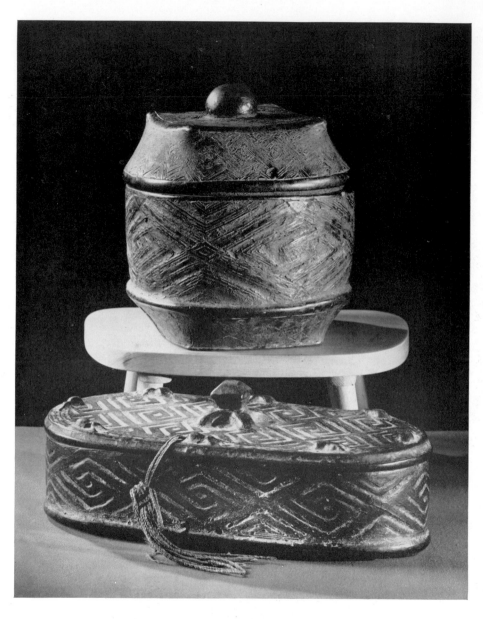

34-D
34-E

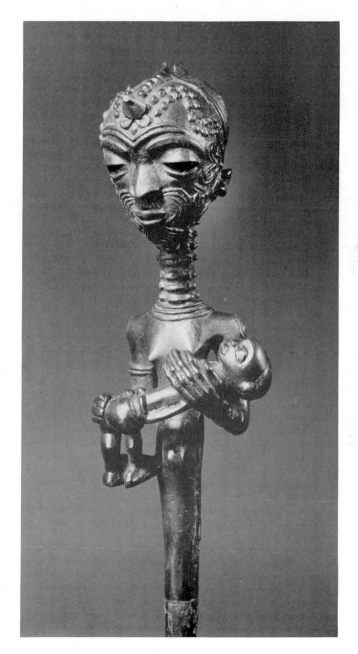

35-B

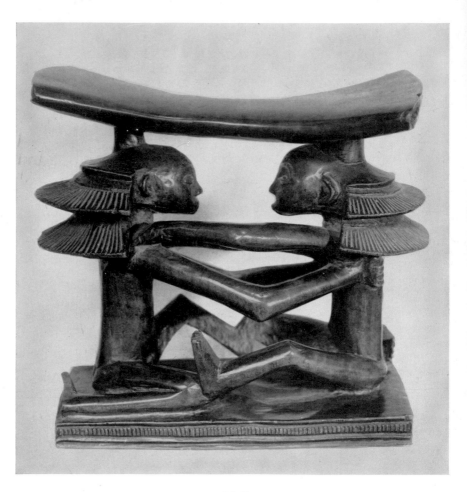

36-C

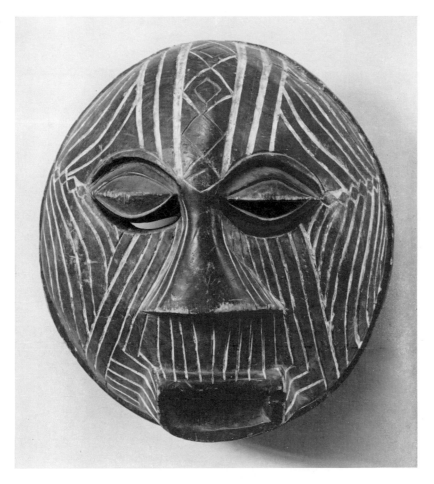

36-I

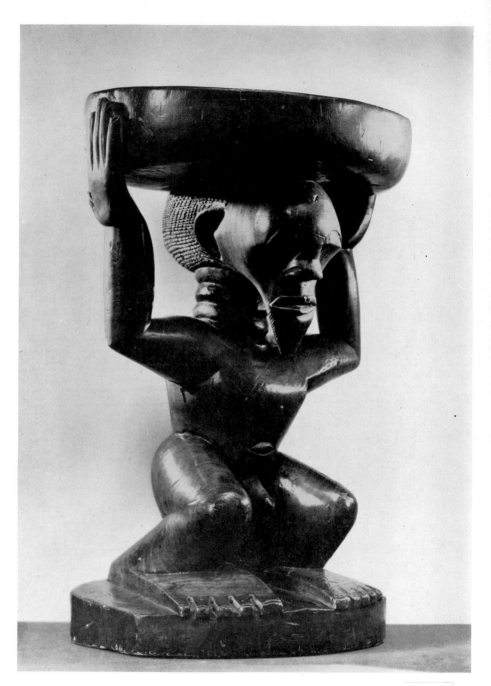

37-E

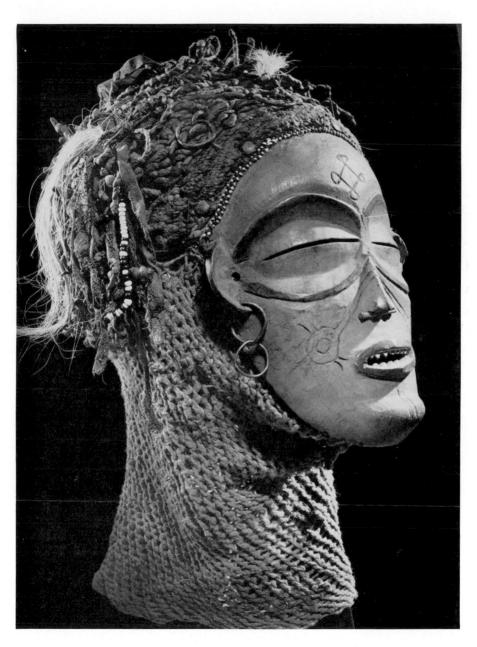

38-B

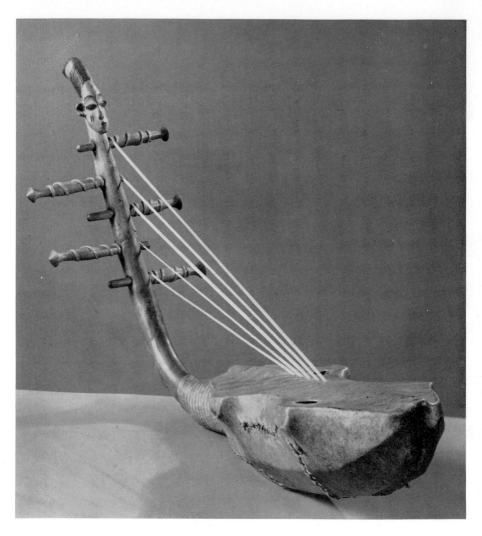

39-A

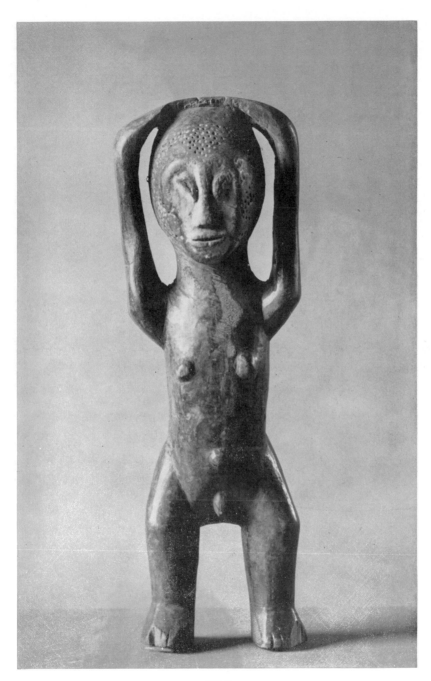

40-B

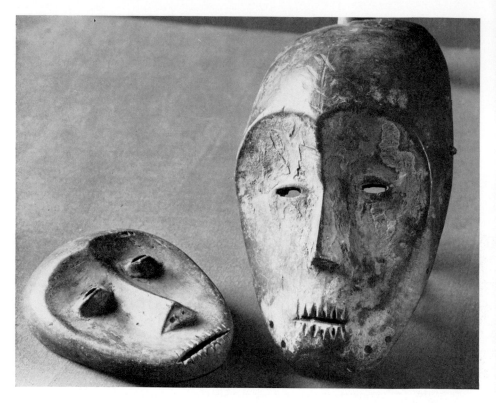

40-D **40-C**

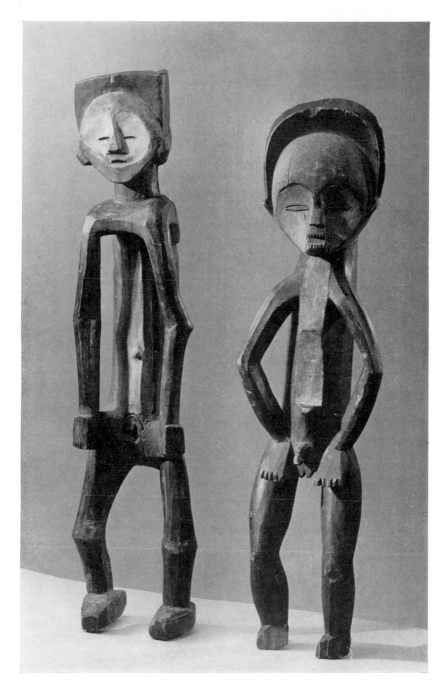

41-A 41-B